IMAGES
of America

SOUTH BRUNSWICK

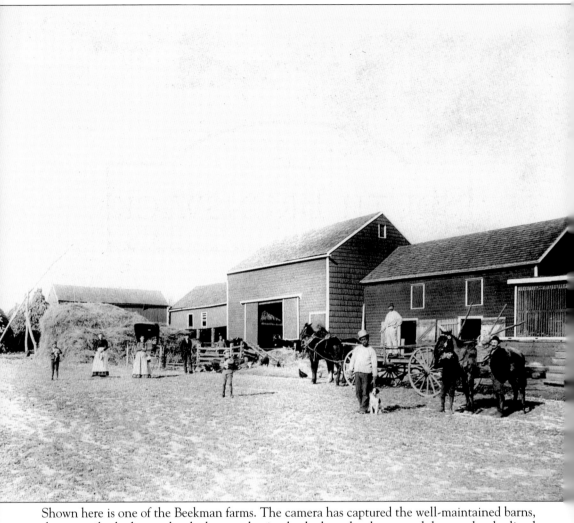

Shown here is one of the Beekman farms. The camera has captured the well-maintained barns, the corncrib, the haystacks, the barnyard animals, the horseless buggy, and the people who lived and worked here.

IMAGES
of America

SOUTH BRUNSWICK

Maria Kotun

ARCADIA
PUBLISHING

Published by Arcadia Publishing
Charleston SC, Chicago IL, Portsmouth NH, San Francisco CA

Printed in the United States of America

Library of Congress Catalog Card Number: 2004102987

For all general information contact Arcadia Publishing at:
Telephone 843-853-2070
Fax 843-853-0044
E-mail sales@arcadiapublishing.com
For customer service and orders:
Toll-Free 1-888-313-2665

Visit us on the Internet at www.arcadiapublishing.com

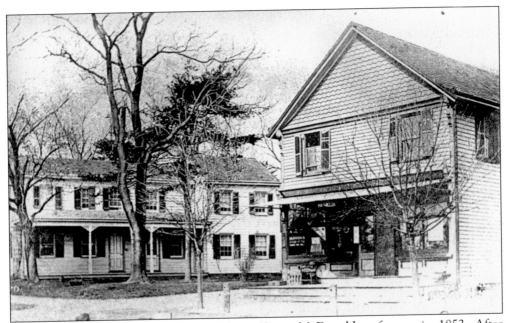

Joseph Moss sold the home on the left to Henry McDonald, a farmer, in 1852. After McDonald's death, George Vanderveer acquired the home in 1894. The other building seen here, also owned by Vanderveer, housed a general store and the Dayton Post Office. The upstairs of this building was known as Vanderveer Hall, and meetings and social events were held there. Both buildings have since been demolished, and a dentist's office now stands on the site.

CONTENTS

ACKNOWLEDGMENTS

South Brunswick is dedicated to my mother, Marie Sierco Guerriero, a woman who has demonstrated unbelievable courage, and to my husband, Michael Kotun, for his support and encouragement. It is also dedicated to my late father, Dominick Guerriero, who was there in spirit to help me complete this book.

With my deepest appreciation and gratitude, I would like to thank the following people, who provided the images that made this pictorial history book a reality: Howard Bellizio Jr.; Bernard Berg; Agnes Shuh Brabson; Nancy Beekman Carringer; Judy and Michael Chiarella; Katherine Kenny Clayton; Edith Anderson Conover; Gloria Copleman; Marie Sierco Guerriero; William Flemer III; Margaret Werner Isak; John Katerba; Joan Olson Kish; Theresa Scurato Kish; Donald Krueger; Frank and Gladys Lidy; George Luck Jr.; Tom Morris, Director of Recreation, South Brunswick Township; Mrs. Meyers; Charlotte Voight Nagy; Dorothy Maul Noebels; Roger Potts; Rev. David Risseeuw; Crawford Robertson; Dorothy (Errickson) and Leroy Skillman; Robert Stewart; Rev. Robert Turton III; Robert Yuell; and Douglas Wolf.

I would also like to extend my appreciation to the following, who allowed me to use images from their collections: Seeley G. Mudd Manuscript Library and the Department of Rare Books and Special Collections of the Princeton University Library, the Historical Society of Princeton, the New Brunswick Public Library, and the South Brunswick Township Recreation Department.

A special word of thanks goes to Mayor Frank Gambatese, Ceil Leedom, and Christopher Carbone, for making possible the use of the photograph, postcard, and slide collections of the South Brunswick Public Library.

Thanks also go to the following local historians, who have made an effort to preserve the history of South Brunswick: William Baker, Richard Stout, Katherine Clayton, and Roger Potts.

The historical information for the captions was obtained from numerous sources, including newspapers, historical books and papers, original documents, and maps. Research was done at the New Jersey Room of Alexander Library at Rutgers, the New Jersey State Archives (through phone conversations and materials sent), Princeton University (through materials sent), the New Jersey State Library, the Middlesex County Archives, the Middlesex County Department of Deeds, and the New Brunswick Public Library.

INTRODUCTION

South Brunswick Township, incorporated in 1798, is located on the southwestern part of Middlesex County in New Jersey. South Brunswick was one of the earliest, most organized, and, historically, one of the most interesting townships lying south of Raritan.

In 1872, the New Jersey State Legislature reduced South Brunswick's size when it established Cranbury Township, and in 1919, land was again taken to form Plainsboro Township. South Brunswick Township was left with approximately 41 square miles of prime farmland, rolling woodlands, and marshy lands with rich indigenous fauna.

As the reader turns the pages of this pictorial journey, the images and captions will reveal the rich historical legacy of South Brunswick. The villages of Dayton, Deans, Franklin Park, Kingston, and Monmouth Junction, along with the hamlets of Little Rocky Hill, Sand Hills, Fresh Pond, Davidson's Mill, and Rhode Hall, contribute to the unique character and colorful history of South Brunswick Township.

Plantations and farms, once abundant in South Brunswick, provide a history of the earliest settlers. Col. John Wetherill, an interesting man, participated briefly in the American Revolution. He had his house ransacked by the British and was known to have put in a claim for damages against Britain.

In 1700, Jediah Higgins certainly understood the art of the deal when he convinced the Native Americans to sell him 1,000 acres of land in exchange for a sow and her litter of pigs.

Woven deeply within the historical fabric of South Brunswick Township are the threads of slave ownership, which existed on the plantations and farms. South Brunswick owes a debt of gratitude to the African Americans who labored in the sun-drenched fields and in the households of the prosperous landowners.

One of the area's treasures is the small farm once owned by the former slave Thomas Titus. Titus obtained the property c. 1817 and lived there with his wife, Sarah, a former slave, and their daughter, Charlotte. Titus officially obtained his freedom in 1818. It is very possible that he was one of the earliest former slaves to own his own farm. Titus died of the plague and was buried on this 10-acre farm.

The book provides an interesting history of the South Brunswick school system as it evolved from a one-room school, attended only by those children whose parents or guardians could pay tuition, to a free public system for all.

The images of *South Brunswick* take the reader on a delightful pictorial journey through quaint villages and charming hamlets. Reflected in this book is the formation of community

coming out of the 18th- into the 19th-century agricultural society, when neighbor helped neighbor to get through the struggles of everyday life.

This book is a must-read for the residents of South Brunswick Township and anyone interested in regional and local history of New Jersey.

One

PLANTATIONS AND FARMS

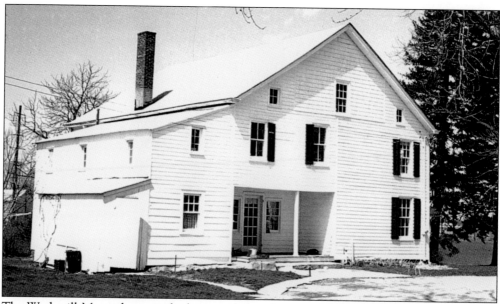

The Wetherill-Mount house is the last remaining element of Col. John Wetherill's plantation. John Wetherill owned the property from c. 1749 until his death in 1784. A man of means and diverse interests, Wetherill was a member of the New Jersey Assembly, representing Middlesex County from 1749 to 1775. He was commissioned a colonel of the 2nd Battalion of Militia of Middlesex County during the American Revolution. In 1782, at the age of 86, he married his second wife, 25-year-old Mary Messler, who gave birth to a son, Vincent Wetherill. The son held the plantation until his death in 1810. Some 13 years later, the heirs of John Wetherill petitioned the court to partition the plantation. The son's widow, Sarah, and her second husband, William Mount, were given 200 acres and the dwelling located on Georges Road, a short distance from Crossroads (Dayton). In the 1980s, the property was developed and the developer gave the house and a few acres to South Brunswick Township. Under the auspices of the South Brunswick Recreation Department, the house has been renovated and maintained.

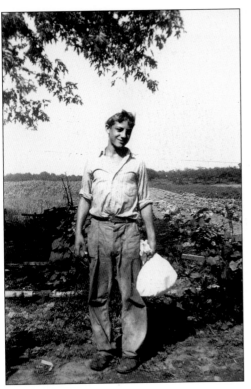

In 1879, Jennie Thorley sold this farm, along with eight other tracts of land, to Margaret and Alexander Fordyce. The Fordyces sold the 62-acre farm to Adeline and Daniel Sierco in the early 1900s. Seen here in 1930, Raymond Petruska smiles for the camera on the Sierco farm. The farm had a large peach and apple orchard, and the fields were planted with corn. The farm was conveyed in 1954 to Marie Sierco Guerriero, and much of it was later sold for the development of Regent Square.

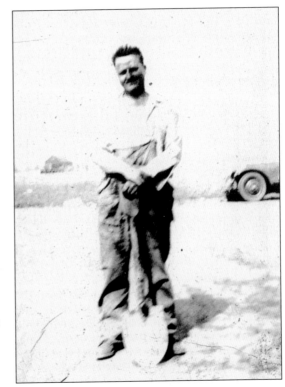

Here, Daniel Sierco stands near his farm on Georges Road, north of Dayton, in the 1920s. In the distance is the home of Sierco's granddaughter, the author of this book, who grew up on this farm.

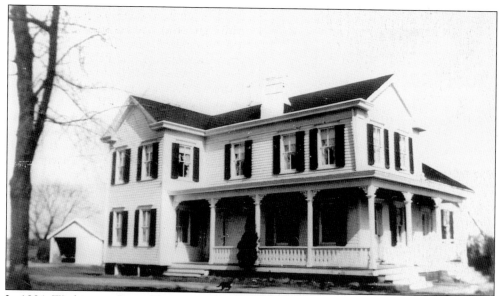

In 1884, Washington Reynolds conveyed to Daniel Applegate 139 acres of land located on the east side of Georges Road outside Dayton. Applegate entered the fair at Waverly in 1887, and won prizes for every variety of apple, pear, and peach grown in his orchard. His son, Wesley Applegate, inherited the farm and dwelling by will in 1895, and the farm was sold by the Applegate family in 1945. The house, pictured here in 1975, was demolished, and Summerfield, a housing development, now occupies the land.

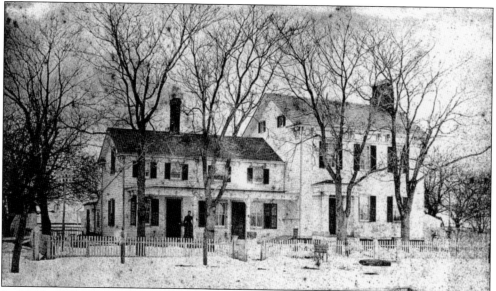

In 1827, William Conover owned this farm on the west side of Georges Road, north of Crossroads (Dayton). Upon Conover's death in 1860, the farm was sold by the family, and in 1872, James Mershon sold it to Daniel Applegate. Daniel Applegate's grandson, Walter, sold the farm in 1943 to Joseph Schwartz, a farmer from Deans. Schwartz's sons, August and Edward, ran their automotive and junkyard business from part of this farm until the property was sold to the developer of Dayton Square in 1973. Shown in the photograph c. 1915 is the Applegate farmhouse.

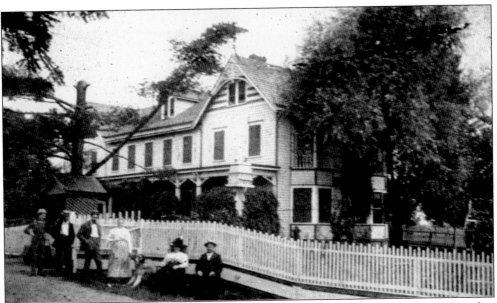

Henry Dorscher emigrated c. 1866 from Germany to Brooklyn, New York. At 17, Dorscher owned his own wholesale business. In 1900, he and his wife, Theresa, purchased this farm in Dayton—once owned by Cornelius Rowland—from Anna Smickle of Manhattan. In 1921, Dorscher, by then a widower, conveyed the farm to his son, Henry, who sold the farm in 1929 to the New York Hungarian Charity Society, an orphanage. The large house on the corner of Route 522 and Highway 130 still stands occupied but now bears little resemblance the way it appears in this c. 1910 photograph.

In 1829, Catherine and Daniel Barricklo inherited from the estate of Ann Barricklo property located on the west side of Georges Road in the village of Crossroads (Dayton). William Ely then purchased the 44-acre tract from Catherine Barricklo in 1839. In 1919, Ely's heirs sold to farmer Charles Oretel, who sold off some of the land in small lots. George and Yolanda Banko acquired the farm in 1945 and, in the 1950s, established a nursery there. The farm dwelling stands unoccupied now, and the eight acres await development.

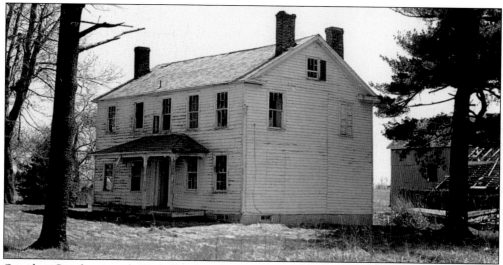

On the Cranbury and New Brunswick Turnpike (Georges Road), near the village of Crossroads, stood the 70-acre farm and dwelling acquired by Charles Groves *c.* 1861. In 1876, Groves sold the farm to Cornelius and Martha Cademus. The land was part of the 200 acres received by Sarah Mount, Vincent Wetherill's widow, when she and the other heirs petitioned the Middlesex County Court to partition John Wetherill's 1,712-acre plantation. In the 20th century, the farm was conveyed to farmers and then to developers. The farm dwelling, shown here *c.* 1975, was demolished and the land is now being developed as the Four Seasons at South Brunswick.

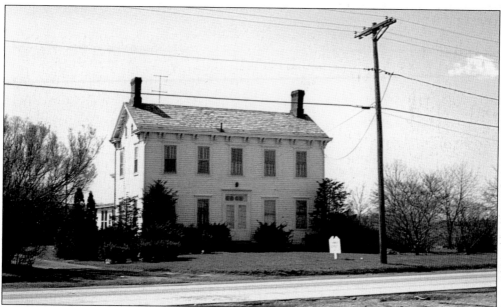

Adjacent to Charles Groves's farm was the farm owned by Ferdinand Van Dyke. Van Dyke left his farm to his mother and heir, Henrietta Van Dyke, who sold the 50-acre property to Joseph Dowgin in 1908. The farm and dwelling, built before 1850, remained in the Dowgin family until 1973, when the property was sold to the AT&T Company. The land was conveyed a number of times, and the dwelling was demolished *c.* 1975. The land is now being developed as the Four Seasons at South Brunswick.

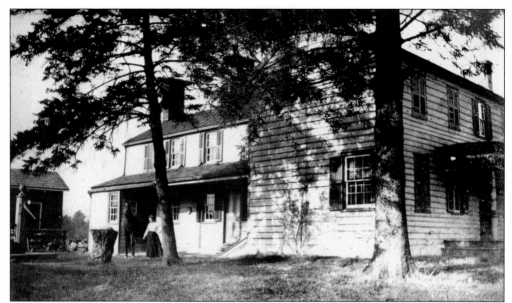

Different members of the Perrine family owned large tracts of land on both sides of the Cranbury and New Brunswick Turnpike (Highway 130). Harriet Perrine acquired this 88-acre farm from Richard Perrine, and she conveyed the property to her only heir, Milton Perrine, in 1922 . Milton Perrine's eldest daughter was born in this house and lived there until her death at age 93. The house now stands unoccupied, awaiting its fate.

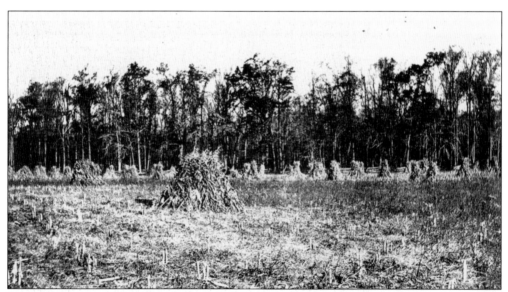

In 1906, when a guest identified only as Ida visited Harriet Perrine's, her camera captured scenes of a working farm, including the land, people, crops, and animals in this self-contained community. Here, Ida photographed the cornfields, with the cornstalks bound together like tepees scattered throughout the field, framed by the woodlot.

14

Ida's camera memorializes the beauty of the pastureland, where cattle and horses were a common sight.

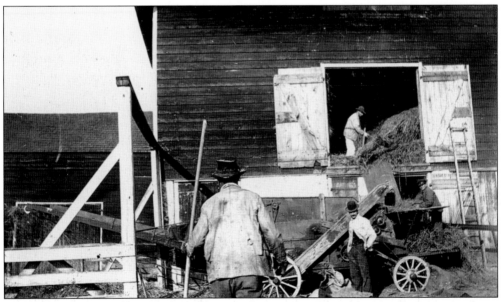

Ida's camera freezes in time the work being done here by the men and a hay press machine, which compresses the hay and bundles it for storage in the hayloft.

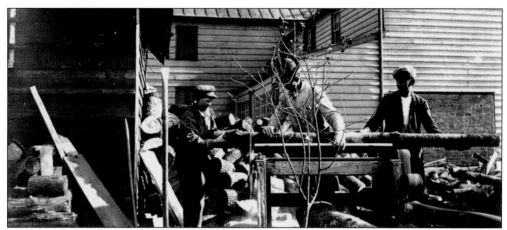

Here, Ida snapped a photograph of a 1906 log-cutting demonstration. The man in the center guides the wood toward the rapidly turning blade, as his two assistants hold the log in place for safety. The logs were obtained from the woodlots.

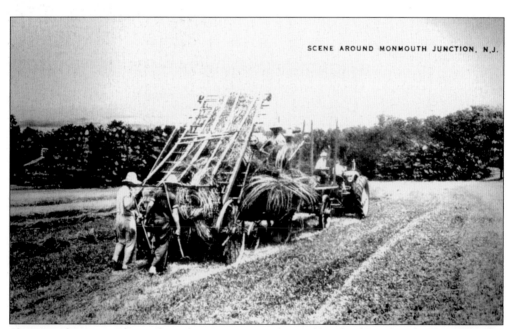

SCENE AROUND MONMOUTH JUNCTION, N.J.

Shown in this postcard view from the 1920s is a mechanical hay loader. After the Civil War, the entire process of hay production had become more mechanical, with the exception of one step of loading. In 1874, the mechanical hay loader appeared and, after a number of improvements, came into use *c.* 1875.

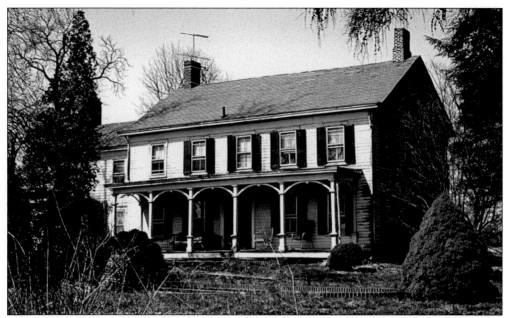

A short distance from the Perrines' farm was the 150-acre farm owned by William Cox *c*. 1861, and inherited by Mrs. William Cox *c*. 1876. It was located on the west side of the Cranbury and New Brunswick Turnpike (Highway 130), just north of Broadway Road.

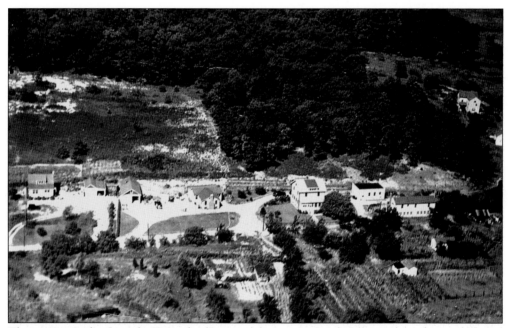

The area near the Straight Turnpike (Route 1) known as Sand Hills was heavily wooded, and was once covered by a thick growth of chestnut trees. The area is interwoven with numerous trails or cart roads that were used by the owners of the woodlots for access to their valuable timber, which was used particularly for fence posts and rails throughout the area. Shown in this aerial view are the houses of the Bellizio family, who have lived in the area for generations.

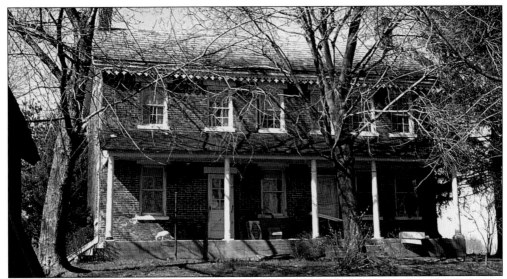

In 1879, John Stolts of Jersey City sold Henry Baker a 100-acre farm that was once a part of the Dean holding. The farm could be reached by turning off the Cranbury and New Brunswick Turnpike (Georges Road) near Deans onto Deans Pond Lane, passing the Deans Mill, continuing through the railroad tunnel, and heading north toward the Straight Turnpike. Henry Baker later conveyed the farm to his son, Henry Baker Jr., who was married there in 1903. In 1918, the son sold the farm to Joseph Daiker, who conveyed it to Fred Daiker in 1930. The Daiker family sold the land to developers in 1970. The house and barns have all been demolished.

In 1844, Richard McDowell, the township clerk for South Brunswick, lived on this farm in Sandy Run (Deans). The farm was formerly owned by the Van Pelt family, whose members are buried under what is now the Deans School playground. McDowell's farmhouse caught fire in 1844, killing the eldest son, Andrew McDowell, and destroying the township records. In 1920, George Walter acquired the farm and operated a dairy farm known as Spring Brook Farms there until the 1950s. In 1963, the farm was sold and the dwelling, shown here c. 1975, was demolished and replaced by a brick residence.

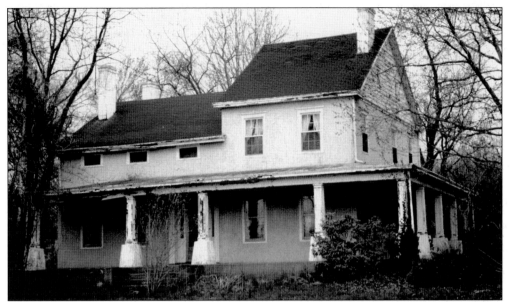

John Henry Martin had a strong influence in the initial growth of the hamlet that bore his name: Martinsville. Martin advertised for sale a piece of property located on the west side of Georges Road. J. S. Conover purchased the land in 1861 and established a grocery, dry goods, and crockery shop there. William Oberman, a furniture maker from New York, later purchased the farm and, in 1985, conveyed the property to his son, William Jr. During the 1940s, Olive and Ethel Oberman operated a pheasant farm there. The farmland has since been developed, and the Oberman house, shown here *c.* 1975, remains occupied to this day.

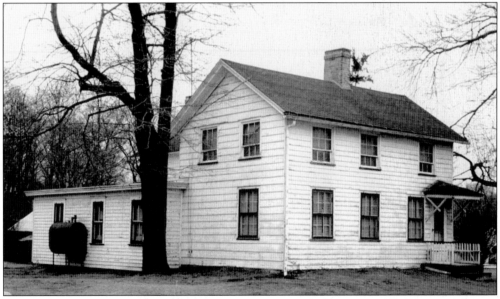

The executors of George A. McDowell's estate conveyed the McDowell farm to Valentine Palmer in 1861. This farm was located on the Cranbury and New Brunswick Turnpike (Georges Road) in the village of Martinsville (Deans), approximately 500 feet northeast of the corner of Road Hall Road. In 1889, Palmer sold the farm to Henry Schramm for $2,850. The farm dwelling, shown here *c.* 1975, was destroyed by fire and replaced by a new residence.

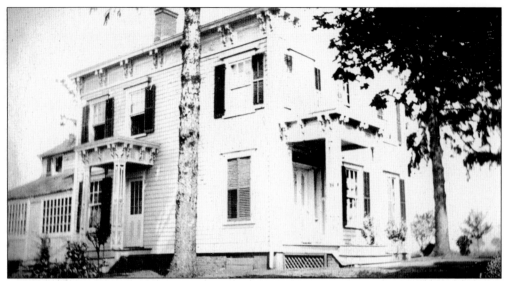

In 1858, John Martin sold this 90-acre farm located in Martinsville (Deans) on Road Hall Road (Deans-Rhode Hall Road) to George I. McDowell. Martin had purchased the land from Barnes Bennett of New York City. The property was a short distance from Martin's apple distillery and the millpond. In 1904, the executors sold the farm for $6,900 to William and Joseph Schuh, who owned a clothing store in Brooklyn, New York. Joseph Schuh acquired William Schuh's interest in 1916. The farmhouse, shown here *c.* 1920, was demolished, and the land was sold to Semitan Investment Company in 1928.

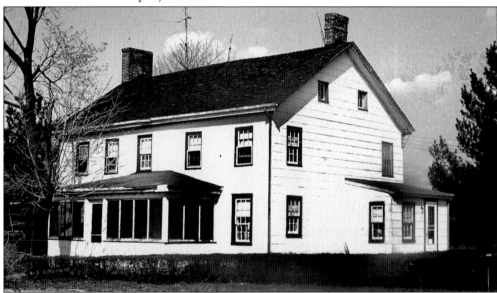

Garrett Terhune conveyed this homestead to his sons, Isaac and Abraham *c.* 1820. The 186-acre Terhune farm was purchased in 1880 by John Terhune. When John Terhune died intestate on July 5, 1898, the property was conveyed to his only heirs of law, his children, subject to the dower rights of his widow, Aletta. In 1906, the Terhune family sold the farm to William and Joseph Schuh. The farm was then conveyed a number of times, and the farmhouse, located on the northeast side of Deans-Rhode Hall Road and Highway 130, was eventually demolished and replaced by a warehouse.

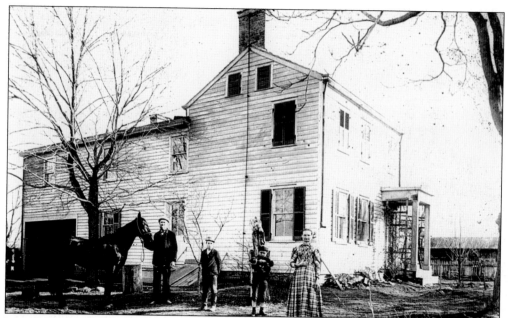

Jehu Pierson, a farmer, settled in the Rhode Hall area in 1750 and married Maria Vanderhoef. His son, Cornelius Pierson, married and remained at Rhode Hall. Cornelius's son, John Pierson, lived on the homestead, shown here *c.* 1910, which was located on the north side of Deans-Rhode Hall Road. The Pierson family sold the farm and dwelling to Frederick and John Kuhn in 1938.

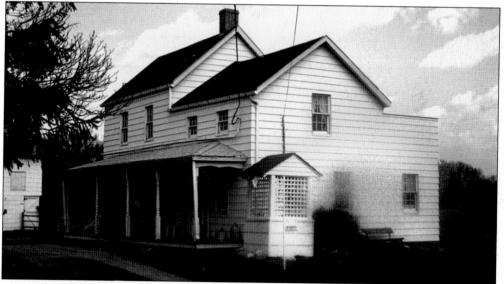

The Deerr family lived on the north side of Davidson's Mill Road near Woodsville (Fresh Ponds) before the Civil War. In 1895, the property was conveyed to Frederick and Jane Deerr by George Deerr, who had owned the property since before 1876. The Deerrs lived there until their deaths in the 1950s. Frederick was a former chain bearer for Andrew Jackson Disbrow, an old-time surveyor and sheriff of Middlesex County from 1881 to 1883. Mary Deerr Petty inherited the dwelling shown *c.* 1975 and lived there until her death in 1979. The home still stands.

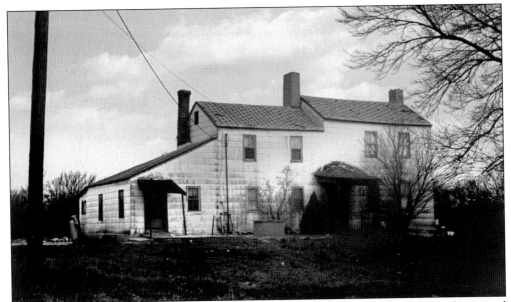

By a commissioner's deed dated April 1847, Jane Combs and her husband, James Reid, received 234 acres of land in the Pigeon Swamp area. In 1851, Jane Combs sold 78 acres from this tract, located on Davidson's Mill Road, to Michael Mulvey, whose widow inherited the 89-acre farm on November 29, 1884. Upon the widow's death, Charles Mulvey purchased the property from the other heirs. In 1916, Mulvey conveyed the farm to Edgar Selover. Currently, the farm is operated as a farmers' market, and the home, shown c. 1975, stands unoccupied.

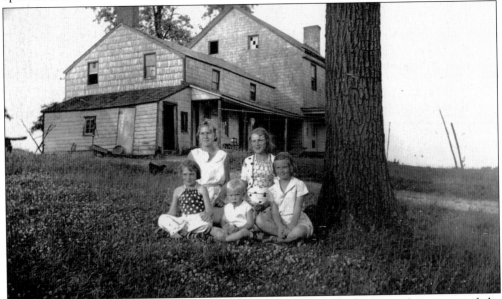

Christopher Columbus Beekman owned this farm in 1876. John Beekman later acquired the property by sheriff's deed in 1904. There were then a number of conveyances, and Freda and John Voight purchased the farm in 1936. Their son, Jesse Voight, and his family now run a horse farm there. Shown in this 1936 photograph are, from left to right, as follows: (first row) Lorretta Voight, Herman Voight, and Mildred Antler; (second row) Rebecca Voight and Charlotte Voight.

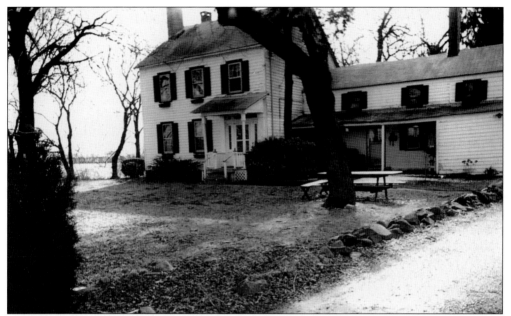

John Van Dyke settled in the Rhode Hall area and married Catherine Reed of Monmouth. The couple's sons, Henry and Richard, remained in the Rhode Hall area and owned several tracts of land on both sides of Davidson's Mill Road. The 166-acre farm was purchased by Henry Van Dyke in 1861 and remained in the Van Dyke family until 1904. The Greek Revival–style farmhouse, built before 1850, stands occupied today.

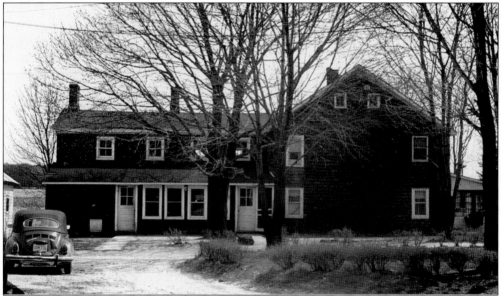

This farmhouse, photographed c. 1975, was located on a farm lane leading southwest from Davidson's Mill Road, about a half a mile northwest of the New Jersey Turnpike. It was destroyed by fire. In 1855, the executor of Catherine Rue's estate conveyed the 110-acre farm to Richhard Reid Van Dyke. It was conveyed in 1911 by the will of Orianna Van Dyke to Howard Van Dyke and was sold to Mustepha and Easeck Ahmed in 1934. The property was sold in 1963, and remains undeveloped.

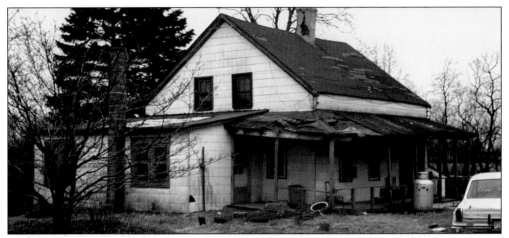

In 1889, this 50-acre farm was conveyed by Jesse Dehart to Edgar Stults. The farmhouse was built before the American Revolution, and it bore markings from British bayonets. Stults conveyed the property to Sarah Gulick in 1896, and her heirs, Witherel Stults and others, conveyed the farm to Harry Forgotson in 1915, who conveyed the farm to Sam Forgotson in 1945.

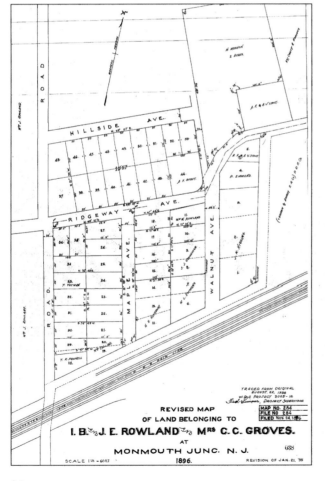

REVISED MAP
OF LAND BELONGING TO
I. B. ⅋ J. E. ROWLAND ⅋ Mᴿˢ C. C. GROVES.
AT
MONMOUTH JUNC. N. J.
SCALE 1 in = 60 ft 1896. REVISION OF JAN. 21, '55

In 1693, the East Jersey province granted 15,600 acres of land to Peter Sonmans. Thomas Lawrence, a wealthy Philadelphia merchant, purchased 800 acres out of this tract. Lawrence named this tract of land, located on the north side of Ridge Road, Longbridge Farms. His daughter, Emily Lawrence Fowler, sold Longbridge to Cornelius Cruser and Frederick Farr in 1834, and that year they sold 268 acres to William Rowland. Rowland later sold 88 acres to his son, Stryker Rowland, a storekeeper in Monmouth Junction, who conveyed the property to his children, Isaac Rowland, James Rowland, and Anne (Rowland) Groves, who subdivided and sold the 88 acres as shown on the Subdivision Map of 1895. This began the developments at Monmouth Junction.

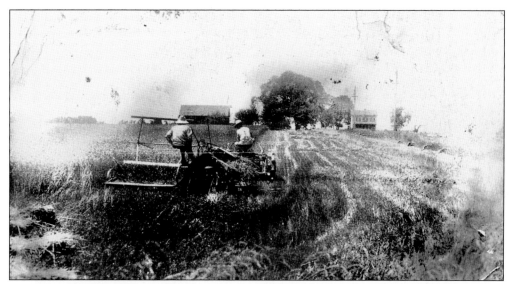

Dr. Nelson Stryker sold a total of three tracts of land located on the north side of Ridge Road in Monmouth Junction to John Voorhees in 1874, 1884, and 1895. In 1905, Voorhees retired from farming and sold the farm to William Emens. Emens rented the farm to Raymond and Helen Anderson, who later purchased the property in 1936 from the heirs of Emens's widow, Mary Emens. Shown here *c.* 1934 are Raymond Anderson (on the tractor) and John Gardener thrashing wheat.

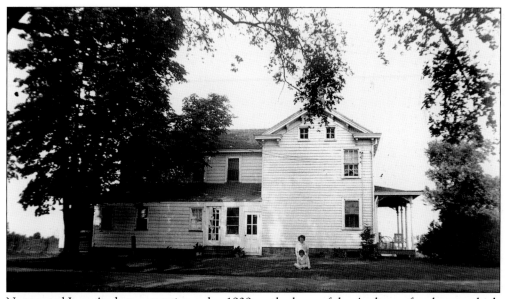

Norma and Jean Anderson are pictured *c.* 1939 on the lawn of the Anderson farmhouse, which was built before 1876. The farmhouse was later demolished, and Raymond Anderson, the girls' father, built a new home on the land. The land was sold *c.* 1970 to the developers of Fresh Impressions. Anderson also owned a second farm, located on the south side of Ridge Road. This farm was acquired by Benjamin Plumley in 1861 and conveyed by will to Abram Plumley in 1912. Abram Plumley sold the land and dwelling to Raymond and Helen Anderson in 1943. The land was eventually sold to Wexford Development.

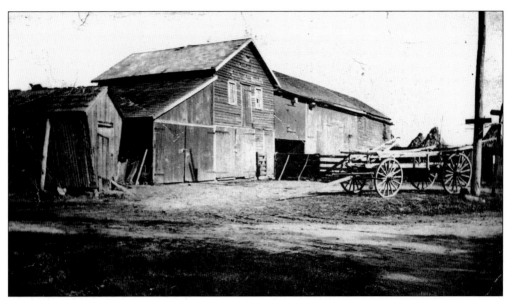

On the northeast corner of Stouts Lane and Ridge Road stood the corncrib and barn owned by Theodore Stewart, shown in this 1915 photograph. The property was sold in the late 1920s to a developer who proposed a development with streets named Cottage, Cherry, and Plum. The property, however, was not developed at that time and, in fact, has only recently been built up with homes.

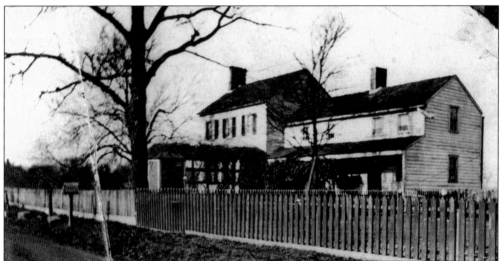

On the northwest corner of Stouts Lane and Ridge Road was the farm acquired by John Rule in 1817 and then by Catherine Rule in 1861. The property was often referred to as Rule's Corner. The Rule family owned properties throughout South Brunswick. In 1876, a blacksmith shop was located on this property. Theodore Stewart purchased this farm c. 1895, when his wife, Catherine Stines Stewart, passed away. Stewart moved his seven children from Franklin Park into the spacious farm dwelling shown here c. 1900. The house was built in three stages, with the center section being the oldest. In 1931, William Flemer of Princeton Nurseries purchased the farm and, in 1961, sold the land to Henry Phipps Estate. South Brunswick High School was eventually built on a section of this farm.

In 1728, William Johnson acquired over 285 acres located on the north side of Ridge Road. In 1792, the property was conveyed by will to his son, Peter. When Peter Johnson died in 1816, the land went equally to his sons, Peter Jr. and John. Peter Johnson Jr. sold his half of the property to blacksmith John Stout in 1816, and John Johnson sold his share to Stout 10 months later. During these conveyances, there were no stipulations written to protect the Johnson family cemetery, where three soldiers from the American Revolution lie. The headstones were removed, and the ground was plowed, making it difficult to determine the exact location of the Johnson cemetery. The Stout family sold the farm in 1940 to William Flemer. A portion of the farm is now part of the South Brunswick High School property.

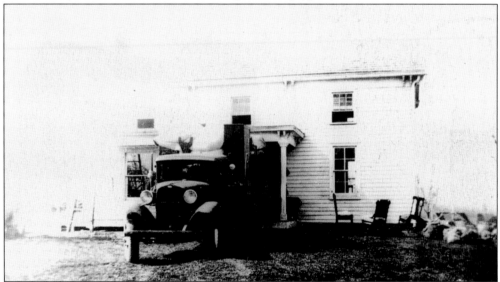

William Flemer of Princeton Nurseries purchased this 40-acre farm, located on the north side of Ridge Road. Richard Kenny, who worked as a foreman for Princeton Nurseries, lived there until 1934, the year of this photograph, which shows the Kenny family moving. William Flemer sold the farm to Leroy and Myrtle Crawford, who conveyed the farm to Jules and Edith Gaylord in 1951. The Gaylords sold the land c. 1994 to the developers of Hickory Ridge.

While attending a party at the Brown farm, located on a long drive off Ridge Road and shown here in the 1920s, Richard Kenny met his future wife, Elizabeth Stewart. Kenny, coming from a farming family, was impressed with the large barns. A few years later, in 1924, the Kennys acquired the farm. Kenny ran a dairy farm there and took the raw milk by truck to Raymond Road and Route 27 in Kingston, where he sold it to Krauzer's Dairy.

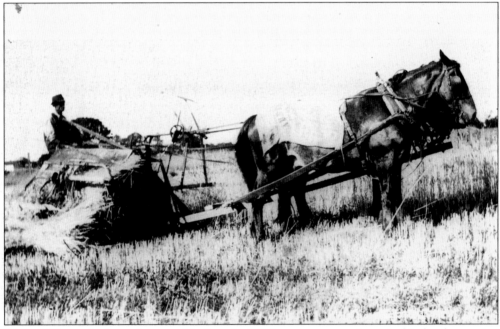

Richard Kenny is shown here on his farm in 1924 on an automatic grain binder, harvesting his wheat. The first automatic grain binder appeared in 1870 and was known as the Locke Machine. The tying device known as the Appleby Knotter appeared c. 1878. It soon became the standard tying mechanism of nearly all modern grain, rice, and corn binders. The binder shown here thrashes the wheat and automatically feeds it into the binder, where it is tied.

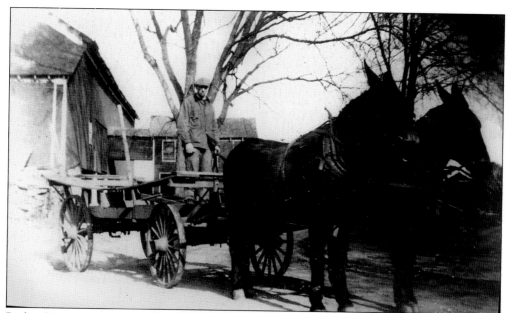

Richard Kenny is shown here in 1924 with his favorite mules, Jack and Jenny. The mule team was hitched to the hay wagon and was on its way to the fields to load the wagon with cut hay. The goal was to transport the hay back to the hay barn before it rained, as moisture would spoil the hay.

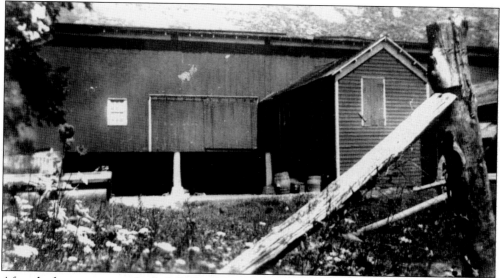

After the hay wagon was loaded, Richard Kenny brought the wagon back to the hay barn and positioned the wagon under the hayloft door. When the door was opened, a clamplike fork was released into the hay. At that point, Elizabeth Kenny, with a team of horses, signaled the horses to move forward as the hay was hoisted into the loft by a rope attached to the horses. When the desired position was reached inside the loft, a trip lever was released, and the fork dropped the hay into the loft for storage.

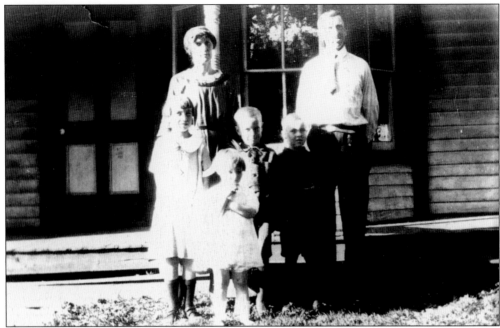

Elizabeth and Richard Kenny pose with their children, from left to right, Katherine, Anna, Richard, and Theodore, in 1928. The Kenny family sold the farm in 1930 to Harry Nevins, who owned a bus line and small airport in Kingston. The Federal Land Bank of Springfield purchased the property in 1935 and sold the farm in 1936 to Robert Flood, who purchased additional land and remodeled the farmhouse. The elegant historic house still stands, although in disrepair, and the surrounding land remains undeveloped.

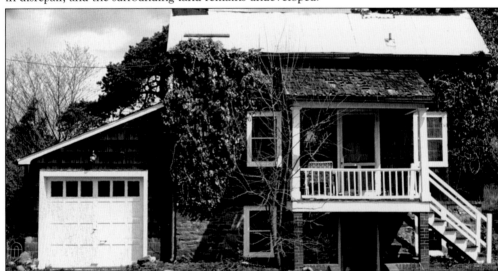

Located on the north side of Ridge Road, near the Straight Turnpike (Route 1), was a small dwelling, built in the 1700s. William Bayles acquired this property (now demolished) in 1850. In 1876, W. C. Haviland purchased the land and house, and in 1896, Mary Haviland conveyed the property to Bayard Stockton of the borough of Princeton. Bayard conveyed the farm a few months later to Agnes Cuyler of South Amboy. After a number of conveyances, William Flemer Jr. of Princeton Nurseries acquired the property.

Taking time out from play to have their photograph taken *c.* 1921 are Theodore Kenny and his sister Katherine Kenny (Clayton), who were living on the farm of their grandparents David and Elizabeth Kenny. In 1918, John Bergen sold the farm (located on the south side of Ridge Road) to the Kenny family, and in 1927, David Kenny sold the farm to Verna Kronnagle. In 1935, Kronnagle conveyed the land to Hiram Landis. The last to farm the land was Earl Renk, who acquired the land in 1941 and eventually sold it to the developers of the Wexford subdivision.

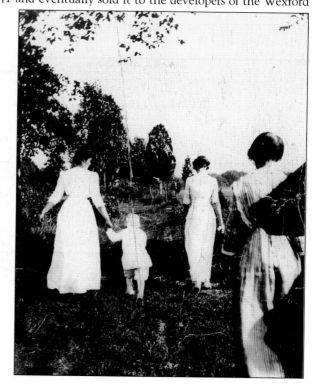

Anna (Stewart) Hunt, the daughter of Theodore and Catherine Stewart, holds the hand of her young son, Franklin, as they enjoy walking together *c.* 1910, on the farm belonging to her and her husband, James Hunt. David Brown sold the farm, located on the south side of Ridge Road, to James Hunt in 1863. Hunt conveyed the property by his will to his son William Hunt, who later conveyed the farm to his children, James Hunt and Mary Deering. James bought Mary's interest in 1917. The land was conveyed to different owners over the years, and it was eventually acquired by Princeton Nurseries. It remains undeveloped today.

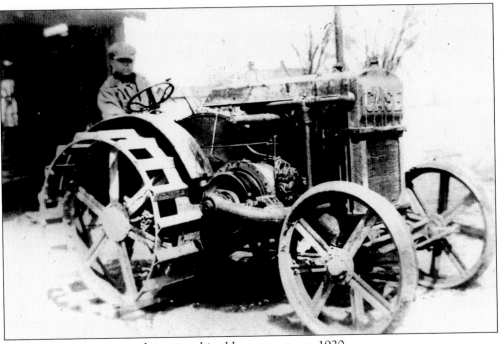

Franklin Hunt appears ready to give this old tractor a try *c.* 1920.

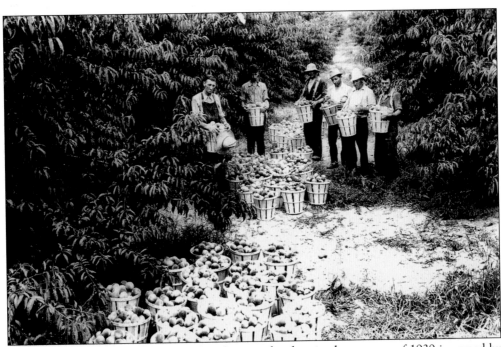

The 40-acre peach orchard seen in this photograph taken in the summer of 1939 is owned by Princeton Nurseries. The peach orchard of Monmouth Junction was considered the largest in the state of New Jersey, with a production rate of 300 baskets of peaches daily. The peaches were picked and prepared for shipment at the old farm implement warehouse in Monmouth Junction, once owned by William Rowland.

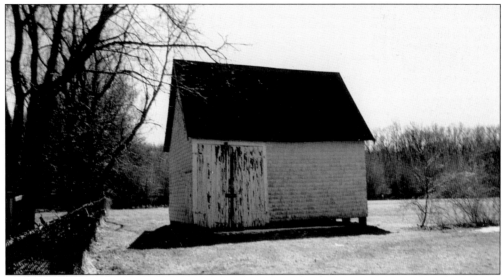

Through a provision in Gerardus Beekman's will, Thomas Titus, a former slave, gained his freedom in 1817. After a manumissions deed was filed and properly recorded in New Brunswick, an official certificate was issued to Titus on August 3, 1818, granting him his freedom. Titus acquired a small tract of land in 1817, shown here in this recent photograph, where he lived with his wife, Sarah, also a former slave of Beekman's, and their daughter, Charlotte. Titus died of the plague in 1849 and was laid to rest on this farm. Charlotte continued to live there until her death in 1859. Her son, Allen Hooper, lived on the farm with his family and grandmother Sarah until he sold the land to Christopher Beekman in 1870. Sarah Titus died in 1876.

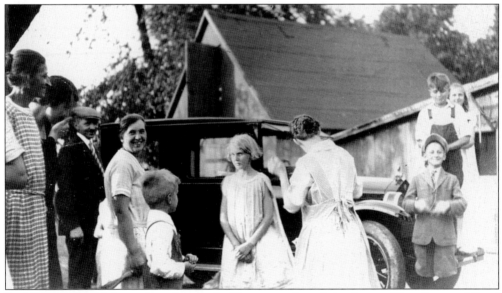

In 1912, Michael Morvacik and his wife, Teresa, purchased the former Titus farm and lived there until their deaths. This 1930 photograph shows the farm and the outbuildings, which are still on the property today. Upon the death of the Morvaciks' son Michael, the farm was conveyed to South Brunswick Township. It is located at the end of Benson Road, in the Kendall Park Development.

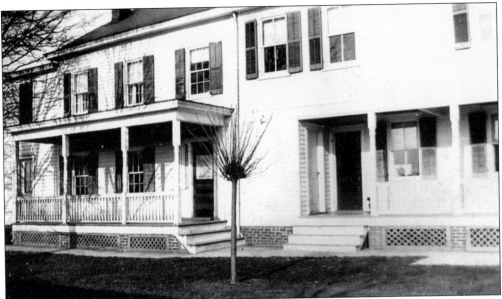

In 1876, Elias Baker conveyed this 88-acre farm to John Hagaman. The farmhouse was built before 1850. Ralph Beekman acquired this property from the Hagaman family in 1906. This photograph of the farm dwelling was taken in 1933, when Ralph Beekman owned it. Elmer Beekman and his wife, Frances, acquired the property in 1969. The land has been sold for development, although the farm dwelling remains standing on Beekman Road.

Ralph Beekman's sons, Elmer and Austin, stand near the hay barn on their father's farm in 1915.

Two

HOUSES OF YESTERDAY

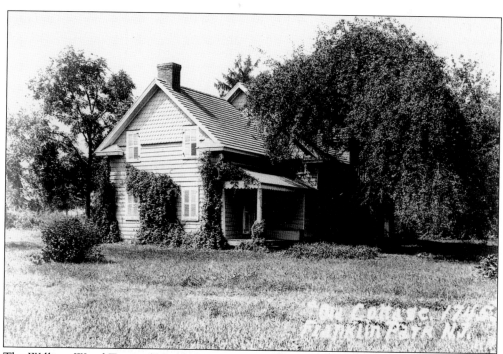

The William Wood Tavern ("the Old Cottage" tavern) was built before 1745 and stood on the Assunpink Trail (Route 27) in the village of Six Mile Run in Somerset County until the road was straightened and the tavern ended up in South Brunswick. In 1759, William Wood's widow, Catherine, owned the tavern. Robert Priest, who served as a drummer boy in the American Revolution, was the next owner. During the building of the Six Mile Run Reformed Church in 1816, some of the workmen boarded at the tavern, then owned by the Priests. The Old Cottage is now the real estate office of Phillip Barrood.

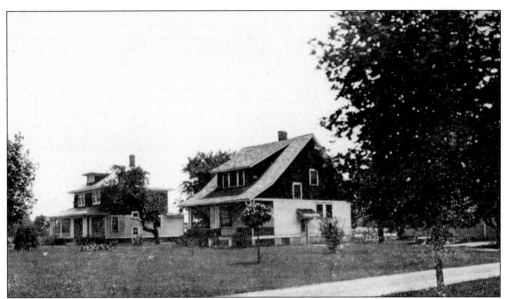

The house on the right in this *c.* 1920 view was built by Lewis Rowland on land purchased in 1912 from Wesley Applegate. Lewis Rowland built a number of small red warehouses, which housed his farm supply business, in the back of his residence. The house on the left was built by Joseph Duncan, a farmer, who purchased the land in 1917 from Wesley Applegate. Both homes stand on the west side of Georges Road, north of Dayton, near the entrance of Dayton Square.

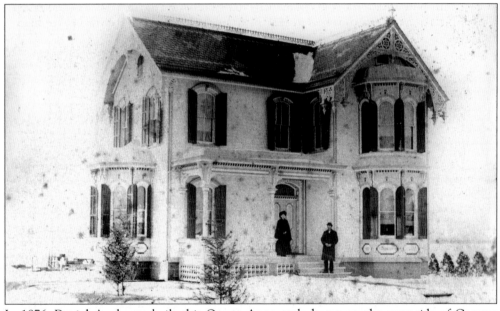

In 1876, Daniel Applegate built this Queen Anne–style home on the west side of Georges Road. Applegate was a prominent citizen and was well-known throughout Middlesex County, having served on the Middlesex County Board of Chosen Freeholders, representing South Brunswick, in 1878 and 1879. Applegate was also one of the principal local dealers in timber, and was a supplier of railroad ties and telegraph poles. The house, pictured *c.* 1900, left the Applegate family when it was sold in 1975.

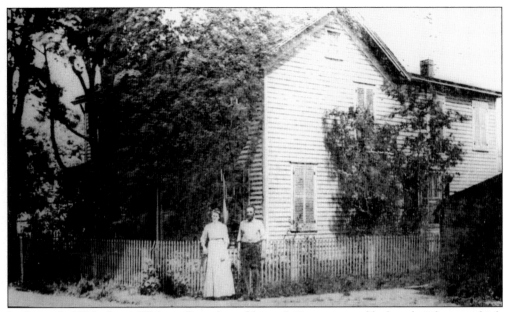

In the early 1900s, James Webster Bastedo and his wife, Lenora, stand before their home, which was located a short distance from Main Street in Dayton, on the road to Monmouth Junction (Ridge Road). William Vanderhoef purchased the blacksmith shop and the land from Andrew Rowland in 1872. James Webster Bastedo then purchased the house and blacksmith shop from Vanderhoef in 1880. When Bastedo died in 1926, his heirs of law conveyed the property to Gorgoniusz Witkowski, who sold the property to Frances and Edward English of Old Bridge in 1946. The residence was conveyed in 1950 to Anne Potter, and is now owned by her heirs.

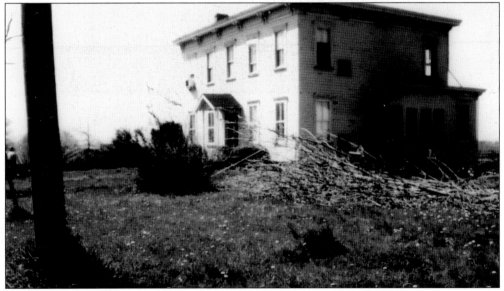

In 1907, the Pennsylvania and Newark Railroad Company purchased properties located in the center of Dayton for a proposed railroad, which was never constructed. In 1942, the railroad sold two tracts of land to Joseph Noebels for $7,000. This residence, photographed in 1982, shortly before demolition, was one of the properties sold to Noebels. It stood on the corner of Culver and Georges Road. The site is now occupied by a shopping center.

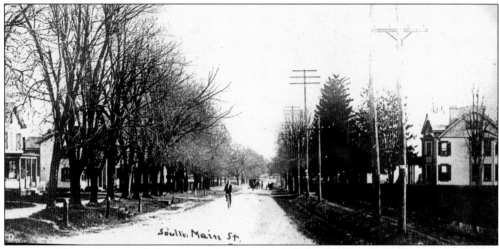

Isaac Snedeker, who owned the Dayton hay press and also manufactured edge tools in the city of Newark, sold land to Joseph Reynolds in 1886. Reynolds, a dealer in grain and fertilizers in Dayton, built his house on Snedeker's former lot, located on the west side of Georges Road. Andrew Ely, who had lost his general store and residence during the fire of 1924, purchased this home in 1926 and lived there until his death in 1936. The house remains occupied today.

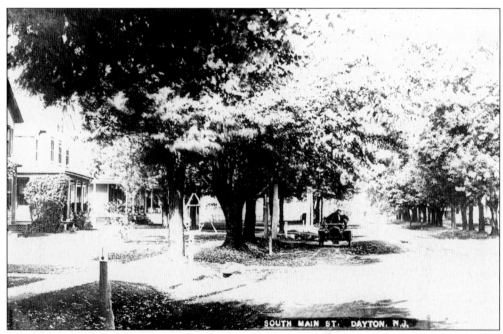

This postcard view of 1923 view shows an automobile making its way down the west side of South Main Street (Georges Road). In the late 1800s, Charles Rowland sold building lots on this side of the street for $100 each. Frank and Mary Osborn, who purchased their lot from Rowland in 1881, built the first home on the left in this view. Osborn ran the country store formerly operated by Thomas Schenck and John Vanderveer. The second home on the right was owned by Elizabeth "Lizzie" and William Conover, who purchased their lot in 1880. Both homes remain part of the village of Dayton.

Shown in this *c.* 1925 postcard view of the east side of South Main Street in Dayton are the properties owned by Gerhardt Noebels, located on land conveyed to him in 1920 by Edward Wilson. After his marriage, Gerhardt Noebels moved from Jamesburg to his new two-story residence in Dayton, built *c.* 1922. The house was demolished in the 1990s. The second home is said to have been moved to this location by Noebels, who sold the house to Peter and Mary Marcols in 1922. The third building was Noebels's garage, which is still in business today.

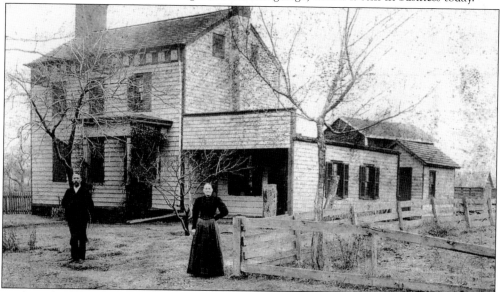

Daniel Bush purchased this home, along with acreage located on Fresh Ponds Road (Griggs Drive) and Jamesburg Road (Ridge Road), before 1850. The people in this undated photograph of the home are unidentified. A Mrs. Anderson owned the house from *c.* 1861 to 1877. Sadie Johnson acquired the property in 1916 and, in 1919, sold it to William Thomas. In 1939, George and Ruth Leffel purchased the home and, in 1974, sold the property. Ruth Leffel began her teaching career in the one-room schoolhouse in Deans and later became principal of Deans School. The house has recently been renovated.

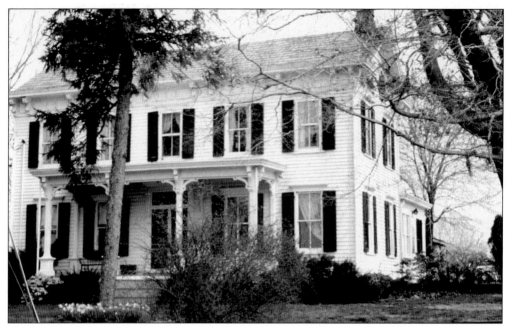

This residence was owned by Cornelius Rowland in 1869. Rowland was a farmer in Dayton. Pictured in 1975, the house is located on the north side of Ridge Road, a short distance from the Highway 130 overpass. The interior has a center hall and a central staircase with double side parlors. The property included 22 acres and a home, which the Rowland heirs sold to James Elmer Griggs in 1914. The home remains a part of the South Brunswick landscape to this day.

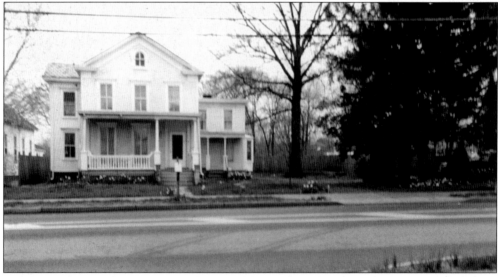

On the northeast side of Georges Road stands an Italianate-style home built *c.* 1870 by Dr. Clarence Mumford Slack. After graduating from Jefferson Medical College in Philadelphia, Slack was appointed by the U.S. Navy in April 1865 to serve as an acting assistant surgeon. He was assigned to the USS *Pembina* during the Civil War and completed his military service in October 1865. A few months later, in 1866, he moved to Dayton, where he began a medical practice. In 1881, Dr. Slack moved to New Brunswick, and in 1883, Dr. Edgar Carroll took over Slack's practice and then purchased the house in 1887.

The Dean family, for whom the community of Deans was named, settled in this area in the 1700s. Innisfree was built on the west side of Georges Road and was in close proximity to Abraham Dean's sawmill, built *c.* 1810. Abraham Dean later built a gristmill, as well. This photograph was taken in 1975 and does not show the slaves' quarters, which were built a short distance from the house and were destroyed by fire in the 1960s. The abolition laws required that owners register the children born to their slaves, or else face penalties. John Dean registered a child named Sally, born to Maria, in September 1807. A child named Hannah was born on March 3, 1809, to Dinah, and was registered by Charity Dean.

Jacob Rightmire built this house on five acres of land that he purchased in 1840 on the east side of Georges Road in Sandy Run (Deans). He was the son of James and Sarah (Van Pelt) Rightmire. Part of the the Rightmire house was was used in 1850 as store and then, in 1861, as a hotel. In 1876, the store reopened. After Jacob Rightmire's death in 1880, his son, Thomas Rightmire, acquired the property and, in 1881, sold the house to his brother, Voorhees Suydam Rightmire, for $2,000. The last Rightmire to reside in the home was Mabel, the wife of Voorhees Alvin Rightmire, who was the son of Voorhees Suydam Rightmire. The landmark house still stands by the little running brook.

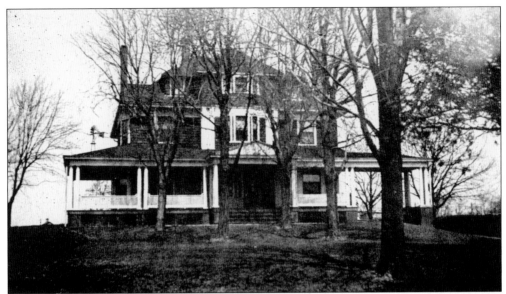

The home of George Waite, located on the west side of Georges Road in Deans, is pictured in the 1900s, before it was destroyed by fire. George Waite was responsible for the establishment of the Middlesex Telephone Company, located on the corner of Hillside Avenue and West New Road in Monmouth Junction. In 1907, Waite conveyed property for the expansion of the Georges Road one-room schoolhouse in Deans.

James Hammell, owner of the apple distillery in Deans, purchased this property, located on the east side of the Cranbury and New Brunswick Turnpike (Georges Road) in 1880 for $700. Hammell sold the property c. 1886 to Catherine and George Gilliand, who converted the building into a residence, a country store, and the Deans Post Office. In 1931, John and Mary Schuh purchased the property from Catherine Gilliand. When John Schuh was appointed tax collector c. 1935, he converted the section of the building that housed the store into his office, which he used until c. 1959, when the first South Brunswick Municipal Building opened on Kingston Lane and Ridge Road. John Schuh was the first full-time township employee. A number of offices now occupy the former residence.

This home was occupied c. 1895 by William Smith. It was located on Old Georges Road, a short distance from Deans. William Smith was a butcher in the late 1800s who went out into the community selling fresh meat off his wagon. He was also the pound keeper for the area and kept any stray cattle in pens until the owners came to claim them. Shown here in 1975, the house is still standing today.

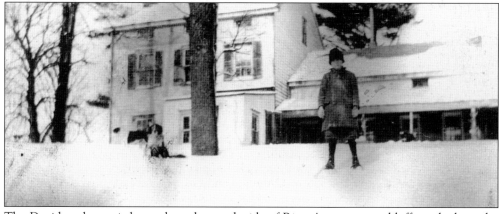

The Davidson house is located on the north side of Riva Avenue, on a bluff overlooking the millpond. Through most of the 19th century, this home was associated with the Davidson family. In 1908, Henry and Clara Werner purchased the house, along with the old gristmill. This wintry scene of 1910 shows the back of the house as it appeared when the Werner family resided there. The home has since been restored.

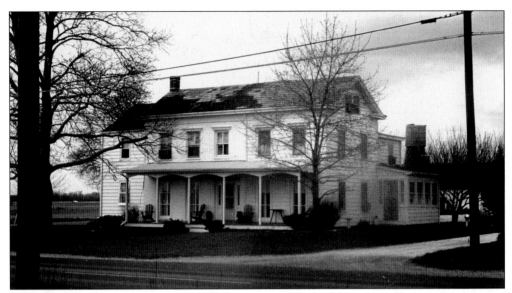

This old farm dwelling, photographed here *c.* 1975, was located on the north corner of Cranbury-South River Road and Deans Hall Rhode Road. The land was part of the Johnson patent. In 1850, a W. Newton occupied this dwelling, and in 1876, a R. Hollman owned it. In 1919, George Kolbus conveyed the property to Frank Sigle. The Sigle family was the last family to reside in this old dwelling before it was demolished.

Shown in this *c.* 1915 postcard view are the homes that stand on Walnut Avenue and Ridge Road in Monmouth Junction, built on land sold by the Rowland family. William L. Rowland, a ticket agent for the railroad, built the house on the left side of Walnut Avenue *c.* 1877. The home with the picket fence on the right of Walnut Avenue was built by general store owner William Emens. Emens sold a lot to his son, Clifford Emens, who built the bungalow *c.* 1910. Peter Emmons, a blacksmith, built the house on the corner of Walnut Avenue and Ridge Road in 1888. owned the house at the end. The small white building in the center was the warehouse and office of A. F. Stout and Son lumberyard. The farmhouse in the center was owned by the Rowland family and was sold to Harvey Mershon in 1896. The homes shown here are now part of Monmouth Junction's Historic District.

In 1895, Anne and Arnold "Farmer" Stout purchased land from the Rowland family and built the Queen Anne–style home on the corner of Ridge Road and Hillside Avenue in Monmouth Junction, a short distance from A. F. Stout and Son lumberyard. In 1929, Augustus and Frank, Anne Stout's executors, sold the house to Elbert and Lafretta Pierson. Lafretta Pierson had worked for Stout as a bookkeeper, and Elbert Pierson had served South Brunswick for 49 years as the township clerk. Lafretta Pierson sold the property in 1977.

This c. 1910 postcard view shows the residence of William J. Rowland and his second wife, Emma Morton, a teacher at Monmouth Junction School, who built this home on the northwest corner of West New Road and Ridge Road c. 1906. In 1884, Rowland was one of the original directors of the First National Bank of Cranbury, now the PNC Bank. On the opposite corner was the residence of John Rowland, William Rowland's son by his first wife, Catherine Barricklo. The house still stands as M. J. Murphy Funeral Home.

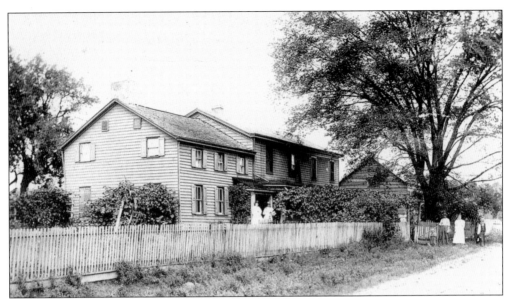

This dwelling was built before 1876 on the south side of the Straight Turnpike (Route 1) in Sand Hills and was owned by Margaretta (Lott) and Louis Gans. Gans and his wife had four children, Katherine, Margaret, Louis Jr., and Mary. This photograph was taken *c.* 1890. The house was later demolished.

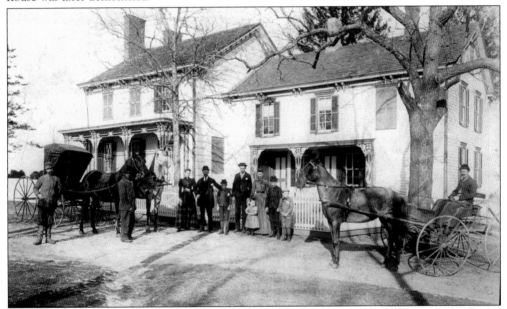

The Beekman house is located on the north side of Beck Court in the Kendall Park section of South Brunswick, and is now enclosed by development. There are two small outbuildings located on the property toward the street. The earliest section of this house, the three-bay section on the right, may have been built in the 1700s. The center was built in the Civil War Italianate style. The last addition (not shown) was built in the late 1800s. John Beekman and his wife, Annie, owned the farm, and their daughters, Helen and Mildred, were the last Beekmans to reside in the house. The present owners have restored the historical integrity of this home.

Shown in this photograph, taken in the 1890s, are John Henry Beekman and his wife, Annie. Beekman was born on November 20, 1872, to Abraham and Emily Spencer Brown Beekman, and he died on November 17, 1922. He married Annie Higgins, who was born on May 5, 1876, and died on October 19, 1935. The Beekmans had three children, John, (1898–1903), Helen, and Mildred.

Shown in this photograph are Mildred Stults Beekman, left, (1912–1951) and Helen Cortelyou Beekman (1904–1951). Both daughters lived in the farmhouse until their deaths in 1951. They never married.

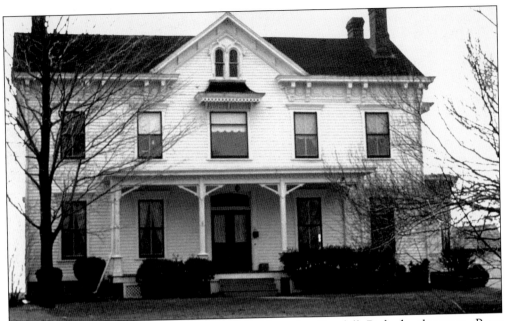

The Cortelyou house stands on Hastings Road in the Kendall Park development. Peter Cortelyou was the son of Henry and Elizabeth Nevius. He was born in South Brunswick in 1796 and spent his youth there. He left the farm, worked in New York City, and then eventually returned to the farm he inherited from his father, Henry Cortelyou. In 1844, he married his second wife, Julia Beekman, and had one son, also named Peter, who inherited the farm when his father died in 1879. The property remained in the Cortelyou family until 1933. The house has since been restored.

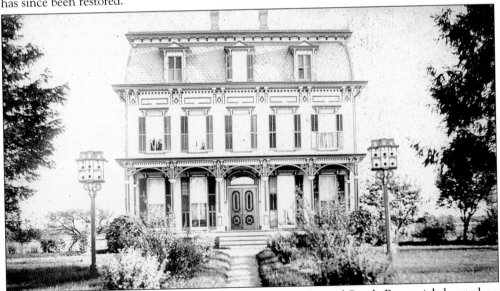

One of the outstanding homes in the Ten Mile Run section of South Brunswick located on Old Stage Road (Route 17)—now Kendall Park—was built c. 1870 by Christopher Beekman (1823–1889) and his wife, Mary Ellen (Stults) Beekman (1829–1903), at a cost of $50,000. In 1946, Mabel Most purchased the property and turned it into the Most Acres Hotel. The house was eventually destroyed by fire.

Shown here in 1907 is Elmer Cortelyou Beekman with his mother, Stella May Cortelyou Beekman, in front of the Christopher Beekman house.

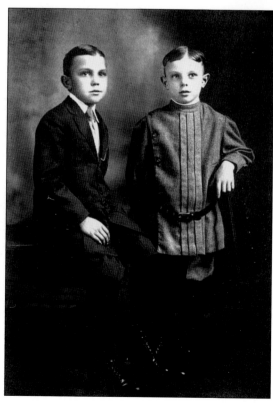

Elmer Cortelyou Beekman, age seven, sits on the bench next to his brother, Austin Stults Beekman, age five, in 1914.

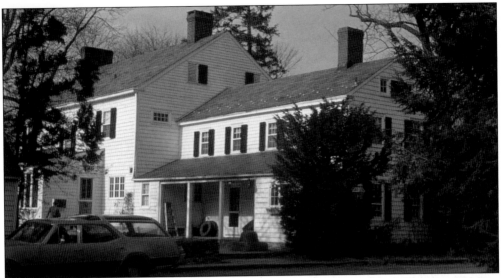

Members of the Bayles family owned this imposing 15-room house, located on the Old Post Road, now known as Main Street, in Kingston. It is said to have been a tavern and stagecoach stop on the Old Post Road. William Bayles purchased the house and land *c.* 1850. During this time, he served as a director of the Gulick Stage Line and the Princeton Bank. In 1857 and 1858, he served on the Middlesex County Board of Chosen Freeholders, representing South Brunswick. In 1876, Alexander Bayles, a farmer, acquired this home. In the 20th century, it was sold to a developer and still stands today.

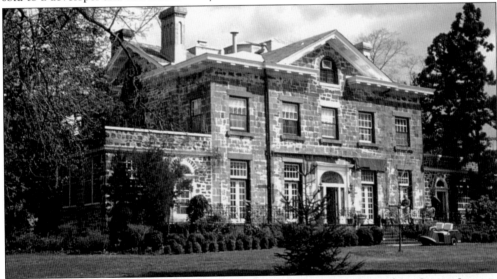

In 1851, Isaac Chandler Withington sold the Withington Estate, located on Spruce Lane in Kingston, to the state of New Jersey. Gov. George Fort purchased the 75-acre tract on behalf of the state to construct a "House of Refuge"—a shelter for juveniles in need of "correctional reformation." The central portion of the house was built immediately, but a lack of state funds resulted in the project being abandoned. Withington, whose permanent residence was in New York City, purchased the property back for use as a summer retreat. Owners of the Withington Estate in the 20th century have included Joseph Garneaux, a wine distributor, and Grace Cook, whose husband was a stockbroker.

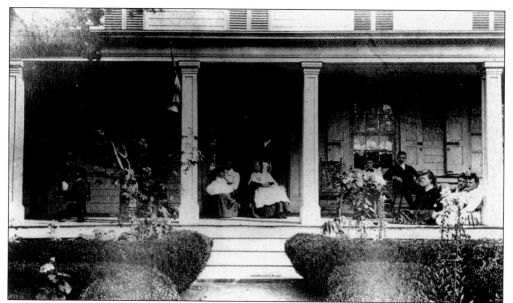

This 1891 photograph shows the summer residence of Andrew Evans of New York, located on the south side of Old Stage Road (Route 27) in Rankling Park. Rev. Jacob Sears of the Six Mile Run Reformed Church in Franklin Park owned the house and land originally. He sold to Annie Evans of Brooklyn, New York, in 1883, for $8,000. From left to right are Mr. Bebee (valet), Mrs. Phillips (housekeeper), Mrs. Charles Rue and her son Charles Teal Rue, Andrew Evans's 100-year-old mother, Andrew Evans, unidentified, Gertrude (Evans) Garretson (to whom Andrew Evans conveyed the property in 1899), unidentified, and Gertrude Thomas. The building is now occupied as a professional office.

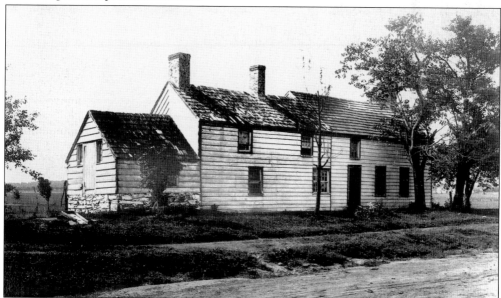

The farmhouse of Asia Higgins, seen in this 1904 photograph, was located a short distance from the road to Deans (Henderson Road) on the southwest side of Old Stage Road (Route 27) in Franklin Park (now known as Kendall Park). William Drake acquired this property c. 1876. He was a mail carrier who delivered mail in the villages of Franklin Park and Deans.

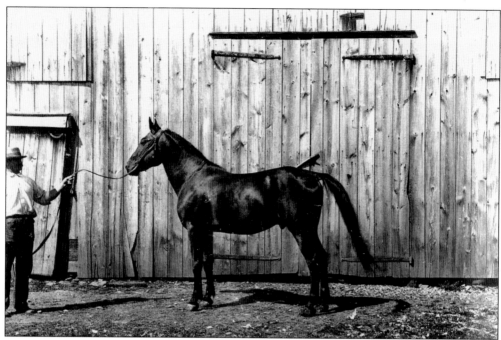

Asia Higgins of Franklin Park shows off his stallion, Jack, on September 29, 1905.

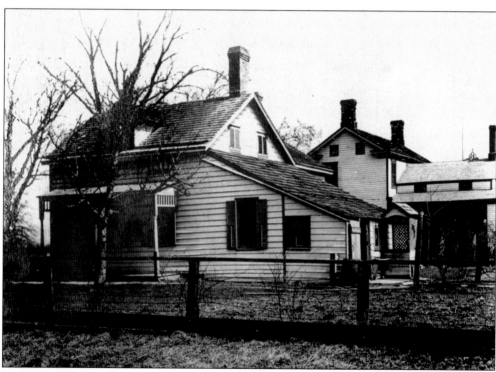

In 1861, when the village was known as Six Mile Run, a Mrs. Stryker occupied this small home. Theodore Williamson occupied this dwelling in 1893, by which time the village was known as Franklin Park. The home was demolished c. 1990.

Three

BUSINESSES OF AN AGRICULTURAL SOCIETY

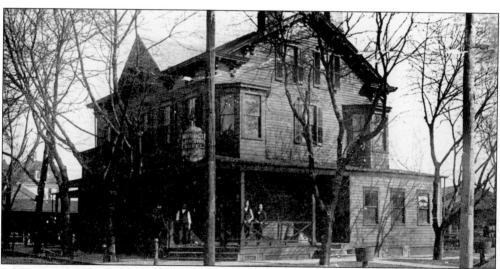

John Henry Martin built the first hotel in Monmouth Junction, at the end of Walnut Avenue near the Pennsylvania Railroad in 1872 on land purchased from Stryker Rowland. In 1876, the hotel was conveyed to James Higgins. After Higgins's death in 1898, his widow, Margaret Higgins sold the hotel to John Elliot of Cranbury. In 1901, Ballantine and Sons Brewing Company acquired the hotel at a sheriff's sale and sold it to Arthur Mount. During his course of ownership, Mount was engaged in an altercation at the hotel with Swift Tarbell over a horse blanket. Tarbell was a sophomore at Princeton University, and his father was the socially prominent Gage Tarbell, vice president of Equitable Life Assurance. Mount struck Tarbell with a club, which resulted in Tarbell losing an eye. Mount was convicted of this assault and sent to prison. The Monmouth Junction Hotel was sold in 1905 and conveyed a number of times before it was destroyed by fire.

In 1841, William Schenck and his wife, Lydia, the heir of innkeeper John Barricklo, conveyed 62 acres and this building to William Jones of New York for $4,500. Jones ran a hotel from this red brick structure, located on the west side of Georges Road, until he conveyed the property to Asa Winchester in 1854. In 1904, Julia Errickson purchased the building and resided there. Here, it is shown in 1975 as a residence before it was converted into Fat Eddie's Groaning Board, a restaurant c. 1978.

This photograph, taken in May 2004, shows the old William Jones Hotel being renovated in preparation for reopening as a restaurant and tavern. The interior was rebuilt, and the original brickwork was retained.

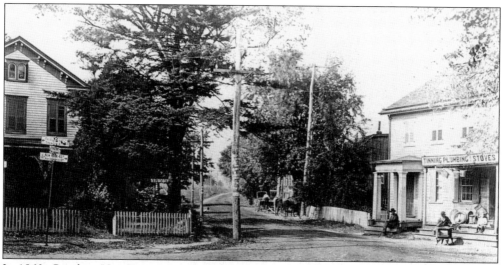

In 1860, Caroline Van Deventer owned this building, located on the northwest corner of the Cranbury and New Brunswick Turnpike and the road to Monmouth Junction, in the village of Crossroads (Dayton). In 1868, John Van Deventer operated a grocery store here. This 1900s photograph shows the building during the time William Thomas rented it for his plumbing, heating, and tinning business. In 1908, George Van Deventer sold this property to Manor Real Estate and Trust Company, a holding company for the Pennsylvania Railroad, for a proposed railroad that was never constructed. The building no longer stands here, and reports say that it was moved from this site to another location.

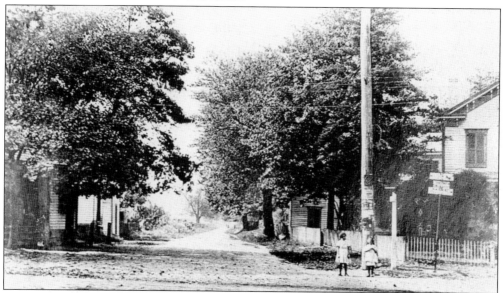

On the southwest corner of the Cranbury and New Brunswick Turnpike and Plainsboro Road (Culver Road) stood the country store that was run in 1868 by Thomas Schenck and John Vanderveer. In 1854, Thomas Schenck was the postmaster of Crossroads. In 1868, John Vanderveer ran the Dayton Post Office from this store. After Vanderveer died and Schenck retired, Frank Osborn, who had worked for these men, ran the country store from the late 1800s into the 1900s. The property was sold in 1907 to the railroad. In 1942, the railroad sold this tract to Joseph Noebels, and it is now the site of a shopping center.

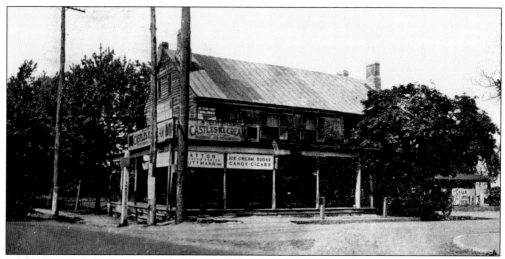

Located on the northeast corner of Georges Road and the road to Road Hall stood the historic Wetherill Tavern, built by Thomas Wetherill before the American Revolution. Wetherill died c. 1817. In the 19th century, the building had a number of owners, including William L. Schenck. In 1848, Schenck ran the Crossroads Post Office from this tavern, also known as the Dayton House. In 1879, Lydia Farr purchased the tavern for $3,100 at a sheriff's sale. The tavern was sold to the railroad in 1907. In 1928, the building was a store and the Dayton Post Office. In 1931, wreckers who came to demolish the building in order to widen the road were astonished by the lumber that had been used to construct the tavern. A convenience store now occupies the site.

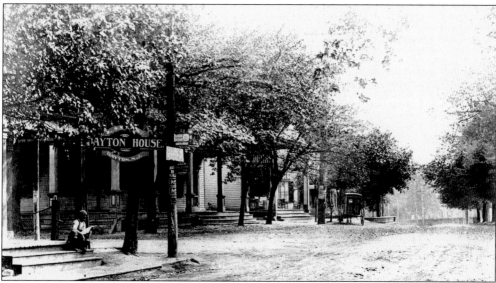

Abraham Terhune owned the Exchange Hotel, affectionately known as "the Old Abraham Hotel," in the 1860s. Built on land once owned by Ann Barricklo, the hotel was located on the southeast corner of Cranbury and New Brunswick Turnpike (Georges Road) and the road to Road Hall, opposite the Dayton House. The South Brunswick Township Committee held its township meetings at the Exchange Hotel in the 1800s. This was the place to vote, come election day. Upon the death of Terhune, Ruth Dean acquired the hotel and tavern in 1889. She sold the hotel to Michael Golden, only to acquire it back later.

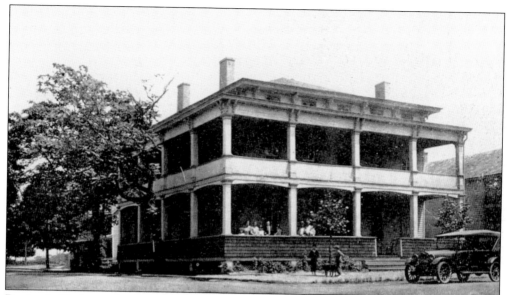

Benjamin Pindrus, a local blacksmith, purchased the Exchange Hotel from the Dean family in 1921. After Jamesburg contractors and a Hightstown firm completed renovations and installed electric lights, the building, shown here in this *c.* 1922 postcard view, opened as the Benny Pindrus Boarding House. On May 1, 1924, the building was conveyed to Michael Sizgovich, and on July 15, 1924, a fire destroyed the boardinghouse. John Errickson purchased the site and constructed a new building there.

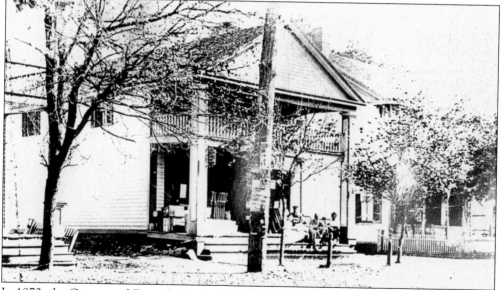

In 1872, the Groves and Ewan Store stood on the southeast side of Georges Road, next to the Exchange Hotel, as seen in this *c.* 1900 photograph. Andrew Ely acquired the store in 1888, and in 1895, he began running the Dayton Post Office. While running the general store, Ely served on the Middlesex County Board of Chosen Freeholders from 1908 to 1917. He also held the position of vice president of the Cranbury National Bank (now the PNC Bank). In 1924, the Pindrus fire destroyed Ely's store and residence. John Errickson purchased the property, and a new general store was built in 1926.

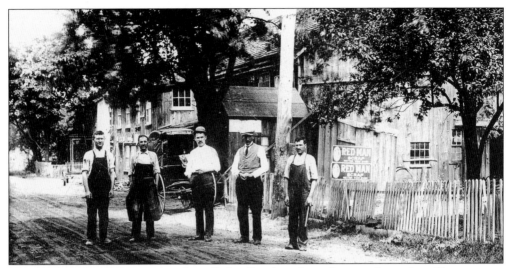

The blacksmiths of Dayton stand on Ridge Road, a short distance from the village center, c. 1910. James Webster Bastedo purchased the shop and residence in 1880 from William Vanderhoef, a blacksmith. In 1926, after Bastedo died intestate, his widow, Lenora Bastedo, and her grown children sold the blacksmith shop and residence to Gorgoniusz Witkowski, another blacksmith. The shop has since been demolished, but the residence remains.

Fritz Luttman was born in Hanover, Germany, and came to America in 1850. In 1875, he worked for Dr. Clarence Slack of Dayton. Luttman later established a harness shop, which is said to have been located on the New Brunswick Turnpike (Georges Road) in the village of Dayton. When Luttman retired, he moved the building to his residence on Ridge Road, where it still stands. He married Mary Beck in 1879 at the Dayton Presbyterian Church. Mary (Beck) Luttman died on November 13, 1939, and Fritz Luttman died in 1941, at the age of 91.

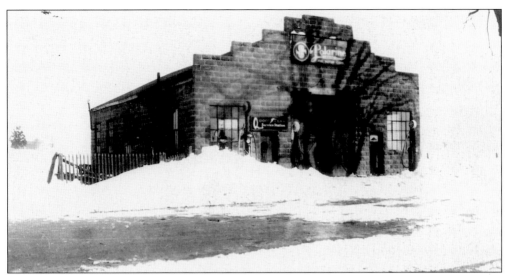

The Dayton Garage, shown c. 1920, is one of the oldest businesses still operating in the village of Dayton. Edward Wilson acquired the property from Anne Francis in 1912. In 1920, Wilson sold the land to Gerhardt Noebels, who then built the garage. Fred Wagenhalls came from Ohio to work on the Trenton and New Brunswick Fast Line trolley c. 1902, and formed a partnership with Noebels in April 1921. The partnership was dissolved in August 1921. In 1927, the garage was sold to Sydney Smalley, who owned it until his death.

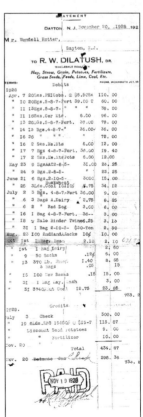

This receipt, dated 1928, is from R. W. Dilatush, located in Dayton on the corner of Hay Press Road and Georges Road. The company was a wholesale dealer in hay, grain, fertilizers, grass seed, and coal. This was the site of the hay press established c. 1876 by Isaac Snedeker. John Errickson established the hay press c. the early 1900s. The other firms that owned these buildings in the 20th century included George Forman and Raymond Dilatush, Dayton Fertilizer Corporation, and Lebanon Chemical Corporation. These buildings are still standing.

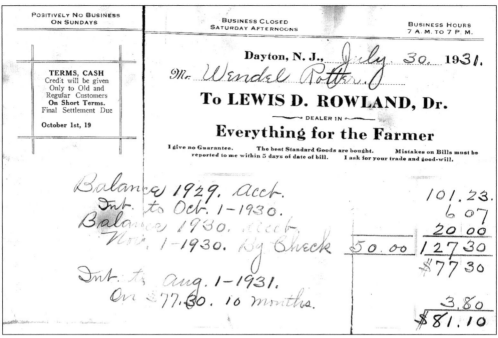

Dayton, N. J., *July 30, 1931.*

Mr. Wendel Potter

To LEWIS D. ROWLAND, Dr.

~ DEALER IN ~

Everything for the Farmer

I give no Guarantee. The best Standard Goods are bought. Mistakes on Bills must be
reported to me within 5 days of date of bill. I ask for your trade and good-will.

Balance 1929. acct.		101.23
Int. to Oct. 1–1930.		6 07
Balance 1930. acct.		20 00
Nov. 1–1930. By Check	50.00	12 30
		$77 30
Int. to Aug. 1–1931.		
On $77.30. 10 months.		3.80
		$81.10

This invoice, dated July 31, 1931, was from the farm supply business owned and operated by Lewis D. Rowland. Rowland's Place, as it was known, was located on the west side of Georges Road north of the village of Dayton, near the entrance of the Wesley Applegate farm, now Dayton Square. Lewis Rowland established this business at that location *c.* 1915 and advertised it as having "Everything for the Farmer." Rowland's Place closed in the late 1950s, and all that remains of the business are the two red warehouses.

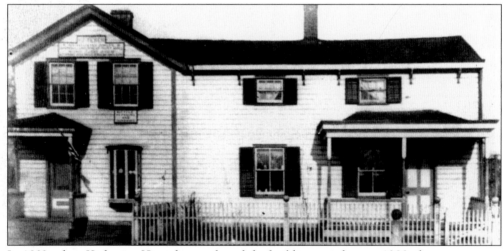

In 1889, when Katherina Himmler purchased the building seen here *c.* 1900, the property was referred to in the deed as the "doublehouse lot." The building was constructed before 1861 on the west side of Georges Road in Deans. In 1895, Himmler conveyed the property to Henry and Mary Weber, who resided in the building on the right and ran a clock-and-watch shop from the building on the left. The Weber family ran a number of different businesses from this building, and in 1963, it became known as Weber's TV and Appliances. The Webers sold the property in 1995, and this building is now occupied by a plumbing business.

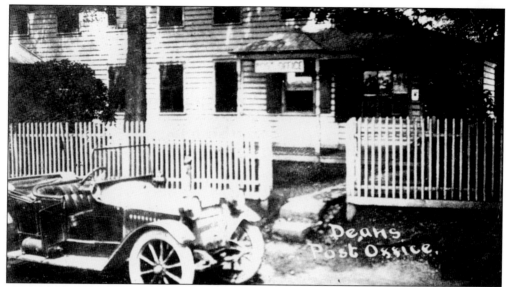

The Himmler house, shown in this c. 1915 photograph, was built before 1861 on the north side of Deans Lane. In 1880, Mary and Patrick McManus of New York acquired this property from Thomas Garret and, in 1891, sold the building to John Himmler. Himmler resided there and ran a harness and shoemaker shop, and when he became postmaster of Deans on July 14, 1914, he ran the post office from this building. Himmler's daughter, Helena, succeeded him as postmaster and served until the Deans Post Office was closed in 1963 and the mail was sent to Monmouth Junction. When she died, the house was sold and demolished.

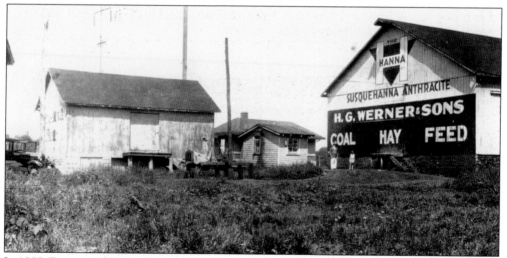

In 1902, Fannie and Harris Hymann sold the hotel located off Deans Lane, near the Pennsylvania Railroad, to Joseph and Philipina Daiker of New York City. The Hymanns purchased the property from Elizabeth Compton in 1893. In 1916, when the Daikers owned the hotel, a tragic murder was committed there. In 1917, the Daikers sold the property to the railroad, which then demolished the building and sold the land to Henry Werner in 1941. Adjacent to the hotel was the hay press, which was established after 1861. In 1907, John Errickson acquired the hay press and then sold it to Ellison Errickson. In 1923, Ellison Errickson sold the buildings and land to Henry Werner and his wife, Clara, who moved their feed and flour business from the Werner gristmill to this property.

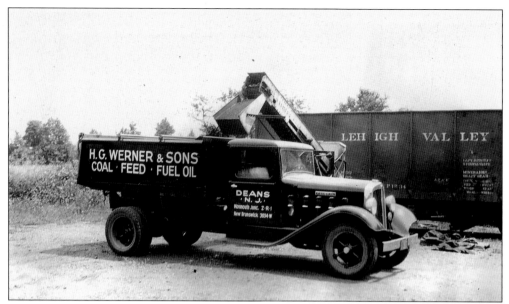

Henry Werner's sons, Frederick and Henry Jr., joined the business and branched out to selling coal and, later, fuel oil. Here, the Werner truck is being filled with coal from the railroad car in 1930. The property remained in the Werner family until Henry Werner Jr.'s daughter, Margaret Isak, sold it in 1969.

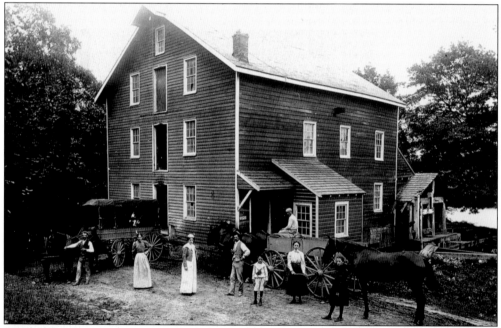

William Cox bought a tract of land from Peter Sonmans *c.* 1733. Cox constructed a dam across the Pisopeck Creek (now, the Lawrence Brook) and built a mill. The mill was purchased in 1768 by John Lawrence, in 1834 by John Davidson, and in 1908 by Henry Werner and his wife, Clara. The Werners sold flour and cracked corn, among other products, and made deliveries by horse and wagon. After a number of conveyances, Stanhope Nixon acquired the building in 1942 and restored it.

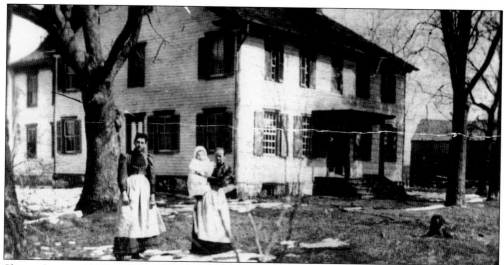

Shown here *c.* 1895 is the tavern-inn established by the pioneer innkeeper David Williamson. Williamson, who came from Scotland, settled in the area with other Scottish families *c.* 1730 and named the area Rhode Hall. The tavern-inn was located on the stagecoach route known as Laurie Road (known today as the Cranbury-South River Road). The road was named after Deputy Governor Laurie, who had the road laid out *c.* 1686 to connect the capital towns of East and West Jersey. Williamson's daughter, Mary, married George Thompson of New Brunswick. After her husband's death, she returned to Rhode Hall and married Thomas McDowell, who purchased her father's estate and engaged in farming and inn keeping.

In 1953, Rose Kish takes a moment out from work in her general store to pose for a photograph. She and her husband, Alexander Kish, started this business in the early 1930s. This was one of the few stores in the area where one could buy fresh meat. The store was located on Ridge Road, near the old Rocky Hill railroad spur, just before entering the village of Monmouth Junction. The property now houses a nursery.

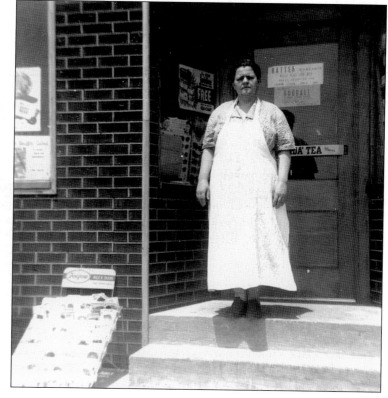

The receipt, showing the printed letterhead:

A. F. STOUT
A. V. STOUT

Monmouth Junction, N. J., *Nov 30* 1900

Mr L. Bosenberry

Bought of A. F. Stout & Son,

WHOLESALE AND RETAIL DEALERS IN

White Marsh Lime, Fertilizers, Grain, Seeds, Feeds, Hardware, Machinery,

→ FARM PRODUCE, ←

COAL, LUMBER, MASON MATERIALS, HARNESS, PAINTS, OILS, ETC.

Terms: _____ Folio _____

Cement	80	
150 a. Cedar Shg 600	98	
10 pcs. lumber	1 00	2 28

Paid
Nov 30 -19 00
A F Stout

The receipt, dated November 1900, is from the business of A. F. Stout and Son of Monmouth Junction. Arnold Stout began this business by selling his family's farm products. He then branched out into selling phosphates, lime, feed, and fertilizers. He also had a small slaughterhouse located near the railroad, off Ridge Road. When the agricultural trade started to decline, Stout's son, Augustus Stout, decided to change the business to lumber and building supplies. The Stouts purchased from Stryker Rowland property on the opposite side of Ridge Road in 1892. The business began with an eight-foot by ten-foot office and warehouse, a wagon scale, and a pole-type shed. The business was expanded over the years, and in 1962, it was sold to William Grander.

The one-story building in which blacksmith Peter Emmons and wheelwrights Walter and Corbit Luker met the demands of the Monmouth Junction agricultural economy was torn down c. 1880. The businesses moved into this two-story building, located near the corner of Walnut Avenue and Ridge Road. Andrew Rowland sold the building in 1892 to Arnold Stout, who added the second two-story building, used a warehouse. William Grander purchased the buildings in 1962.

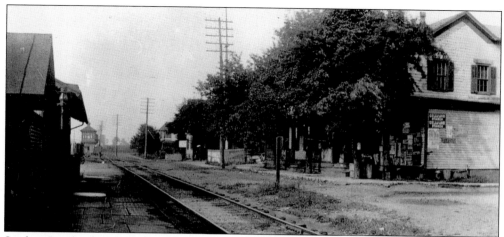

Stryker Rowland operated a general store on Walnut Avenue near the railroad tracks in Monmouth Junction and was postmaster in 1870. He conveyed the store to Richard Rowland, who served as postmaster in 1874. Charles Groves of Dayton purchased the building and business, shown here in this *c.* 1936 postcard view, from Richard Rowland in 1887. Groves's son, Harvey Groves, ran the general store and was postmaster in 1879. When the son left the business, John Race ran the general store and was postmaster in 1882. Charles Groves sold the building and general store to William Emens in 1879, and Emens served as postmaster in 1886 and 1894. The Emens family continued to run the post office from this building from 1951 until the new post office was built. The old building was sold in 1965 to William Perrine, and it was eventually demolished.

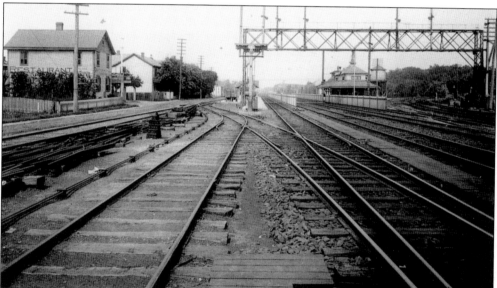

Henry Hathaway, who had worked as a clerk in Harvey Groves's general store in the 1880s, owned the building on the left in the 1890s. Pictured *c.* 1900, the building was located off Maple Street, near the Monmouth Junction railroad tracks, a short distance from Groves's general store. It housed a restaurant, tobacco shop, and Hathaway's horse-trading and carriage rental business. The Monmouth Junction Post Office was located here when Hathaway was appointed postmaster in 1889, 1899, and 1907. Hathaway sold the building to James Law in 1908. Law then sold it to Luther Bossomberry. The building was later sold and demolished.

This photograph, taken *c.* 1943, shows Capt. William Voorhees of the Monmouth Junction First Aid Squad giving a first-aid demonstration at Elbert Pierson's grocery store, located on the east side of Ridge Road. In 1913, Elbert Pierson rented the store from William Rowland and continued to run the business until 1943. The store remained until the 1950s when, as Rocco Melfry's Store, it burned to the ground. The approach to the East New Road railroad overpass now runs through the spot where the store once stood.

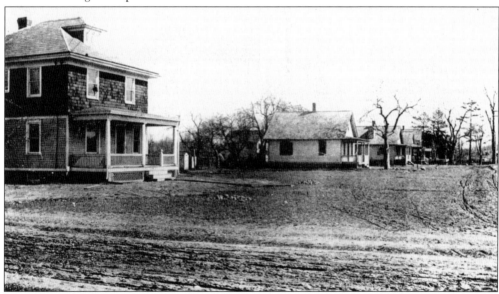

In 1906, George Waite of Deans established the Middlesex Telephone Company on the second floor of this corner house, located on Hillside Avenue and West New Road in Monmouth Junction. George Waite was the president, and William Emens was the manager and treasurer. The company existed for almost 23 years before it became part of the New Jersey Bell Telephone Company. The house was sold on December 30, 1941, to John and Maria Yaros.

Shown in this 1910 view are the buildings owned by J. Watson Shann, on Railroad Avenue (Heathcote Road) in Kingston. The large building housed the wheelwright shop on the ground floor and J. Watson Shann's mortuary on the second floor. The smaller building housed the hearse. In 1901, a complete funeral by J. Watson Shann cost $69. Shann's widow, Matilda, sold the property to the Kingston Volunteer Fire Department in 1926 for $3,000.

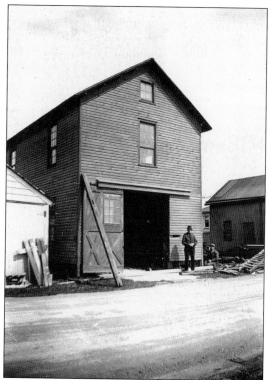

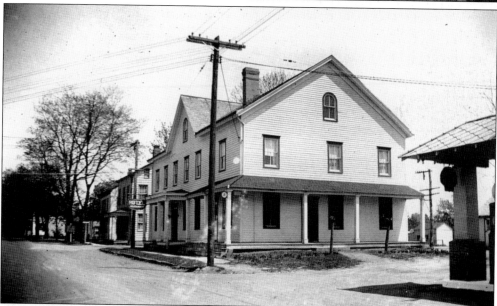

Phineas Withington was the earliest proprietor known to have run the historic tavern located on Old Stage Road in Kingston, which was built before 1776 and which after 1810, was known as the Withington Tavern. Withington, a descendant of an old New England family, was born in 1790 in Jamaica Plain, Massachusetts. In 1810, he moved to Kingston, where he became one of the proprietors of the Union Stage Line and ran the Withington Tavern. The Union Line Hotel (shown here) was built c. 1879 on the site of the Withington Tavern.

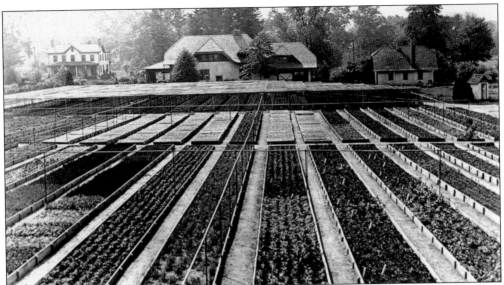

In 1911, William Flemer Sr., founder of Princeton Nurseries, moved his nursery from Springfield to Kingston. He wanted to move the nursery to Princeton, but the land he had in mind was owned by Princeton University. He then purchased approximately 265 acres on Mapleton Road. Through the years, Princeton Nurseries owned farmland on both sides of Ridge Road and on Stouts Lane in Monmouth Junction. This view of the frames, lath house, and office, was taken at Princeton Nurseries in 1926.

This large frame house was located on the southeast side of Route 27. Surveyor Azariah Dunham called it "the Widow Hoagland's Place" in 1850 and 1876. The old farm dwelling was converted into the Three Acres Tavern, and in 1975, when this photograph was taken, it was owned by Joseph Lojko. The tavern was later destroyed by fire.

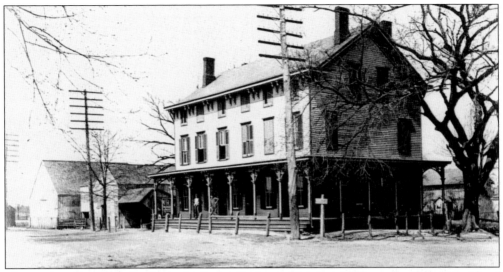

Christopher Columbus Beekman built the Beekman Hotel *c.* 1876 on the Somerset side of Route 27, on land occupied by taverns since Colonial times. Gilford Tavern occupied the site during the American Revolution, and from 1776 to 1868, Monroe Baker and his son, William, kept the tavern. William Williamson ran it as the Franklin House from 1868 to 1874. The building was torn down in 1874 and replaced by the Beekman Hotel, which was destroyed by fire in December 1929.

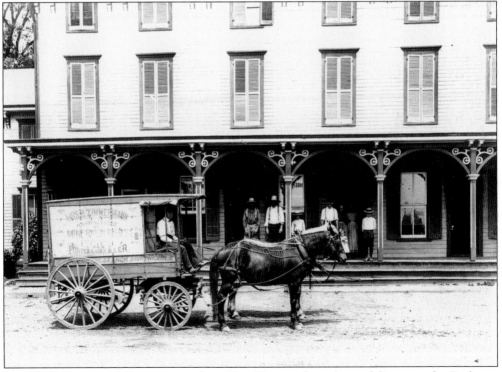

Mrs. B. Zimmermann's beer wagon, from New Brunswick, makes a delivery to the Beekman Hotel in June 1906. Mrs. Zimmermann sold mineral water, ale, and porter and lager beer. On the porch are, from left to right, Elias Cortelyou, Edward Smith, and several unidentified people.

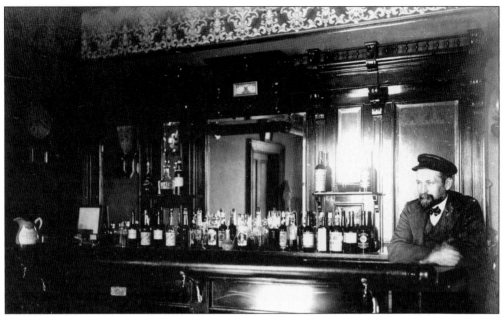

At 4:10 p.m. on December 9, 1904, John Crawford, the proprietor of the Beekman Hotel Bar, rests comfortably on the elegantly carved bar, which was built in New York. In the center of the bar, over the mirror, is the first dollar the establishment made.

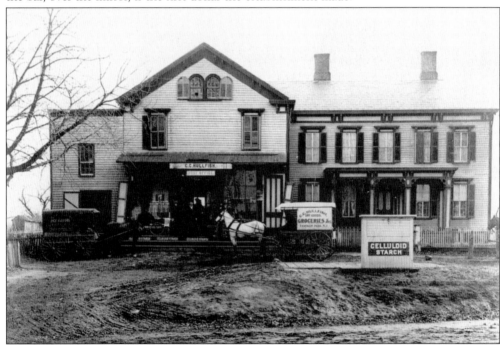

Christopher Columbus Beekman owned this building c. 1876, which housed the general store and post office for the village of Six Mile Run (later called Franklin Park). The store was located on Old Stage Road (Route 27), north of Henderson Road, in South Brunswick. This photograph was taken in 1905, and all that remains of this historic structure now is the center section, which was converted into apartments.

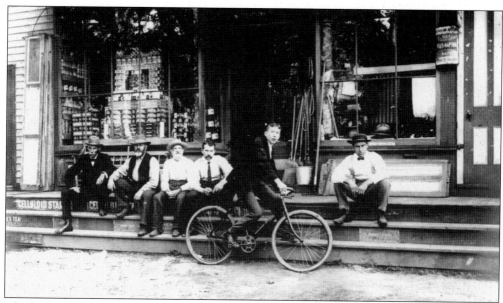

Charles Hullfish owned the Beekman general store *c.* 1893, and it was a favorite gathering place among the locals. Pictured in September 1905 are, from left to right, John Meseron, Cornelius J. Van Derveer, James Hullfish, Charles Hullfish, his son Lester, and his clerk Pierson.

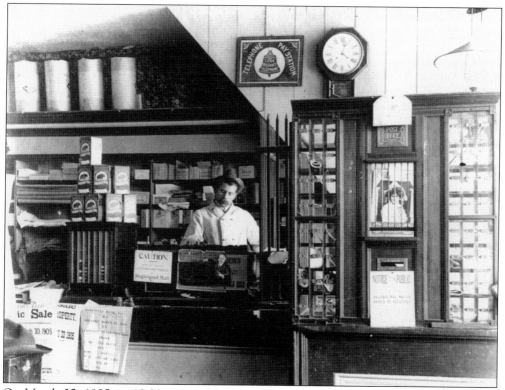

On March 25, 1905, at 12:20 p.m., postmaster Charles Hullfish is busy at his Franklin Park Post Office desk.

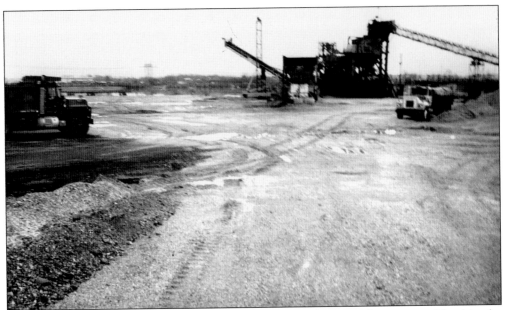

In 1780, the New Jersey State Legislature enacted a law that gave the owners of land in the Pigeon Swamp area the right to open and keep clear of obstructions a watercourse that emptied into the Great Ditch, dug for the purpose of draining this area for agriculture. The law required that three managers be appointed to see that the owners complied and paid taxes. Alexander Van Aken, who owned over 140 acres in Pigeon Swamp, was appointed as one of the managers in 1892. His property is now owned by the Dallenbach Sand Company, which began a dredging operation in 1945, as shown in this recent photograph above. The efforts to drain the area in the 1700s were not a success, and for over 200 years, the Pigeon Swamp area has defied any attempt to drain it. The view below of the swamp, taken from Dallenbach Sand Company, shows the incredible beauty of this unspoiled area.

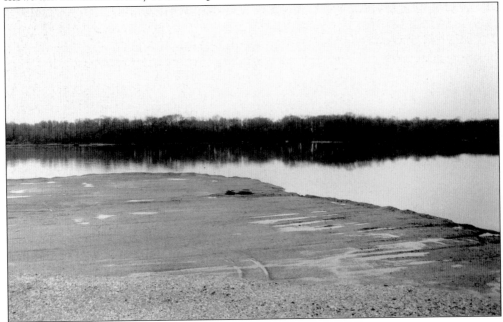

Four

TRANSPORTATION

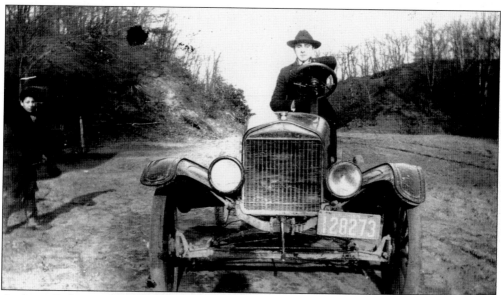

Anthony Spilatore of Sand Hills is pictured behind the wheel in 1915 on a dirt road now known as U.S. Route 1. A private company built the Trenton and New Brunswick Turnpike, which was completed c. 1807. The toll road was 66 feet wide and was referred to as "the Straight Turnpike." The company abandoned the road c. 1900, and it became the burden of the counties to repair and maintain it. In 1927, it was taken over by the state of New Jersey and widened to 100 feet. When it opened to the public, it was known as "the Super Highway" (Route 26). Using federal funds, it was widened to four lanes in 1937, and in 1953, it was renamed United States Highway Route 1.

Shown in this c. 1900 postcard view is Georges Road. Georges Road was originally an Indian path known as the Crosswicksung Trail. It led from the Raritan River in New Brunswick, southeast through the heart of South Brunswick, to Cranbury. In the 1800s, it became a toll road known as the Cranbury and New Brunswick Turnpike, built by a private company, with tollgates at intervals of several miles. Middlesex County assumed responsibility for the road c. 1900. By a legislative act of 1925, the road was taken over by the state highway department as the forerunner of what is now U.S. Route 130, which bypasses Deans, Dayton, and Cranbury.

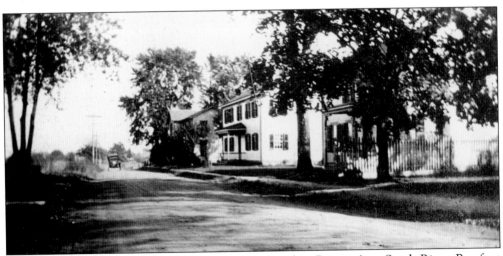

Ridge Road was known as the road leading from Barefoot Brunson's to South River. Barefoot Brunson's house, now known as the Gulick house, is located just west of the Millstone River, near the former Kingston Flour Mills. This portion of the road, shown here in the early 1900s in the village of Dayton, was called the road to Road Hall (Rhode Hall), the road to Jamesburg, and the road to Brown's Corner, and is now known as Ridge Road.

The road that today is state Route 27 was originally an Indian footpath known as the Assunpink Trail. The road was also used by the English settlers of Elizabethtown to reach the falls of the Delaware River (Trenton). It was also known as the Old Stage Road, as the stagecoach traveled this route between New York and Philadelphia. In 1913, the road was designated part of the Lincoln Highway.

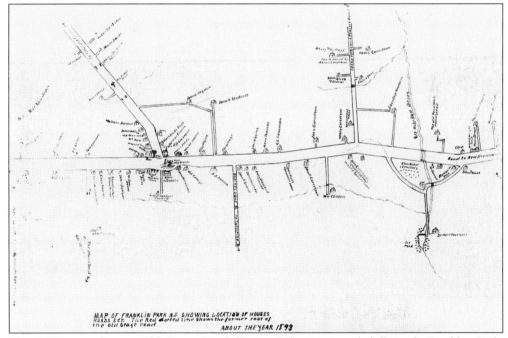

This 1893 map depicts Old Stage Road (Route 27) as it traveled through Franklin Park. The road created the western and northwestern borders of South Brunswick and divided the counties of Somerset and Middlesex.

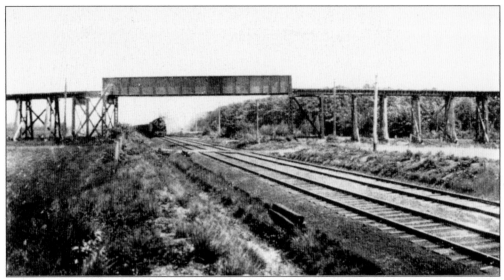

A total of 28 bridges were constructed along the Trenton and New Brunswick trolley route. The Dayton Bridge, shown in this *c.* 1920 postcard view, was the largest of them. The Pennsylvania Steel Company of Steelton, Pennsylvania, erected this bridge for the Trenton and New Brunswick Railroad Company over the tracks of the Freehold and Jamesburg branch of the Pennsylvania Railroad in 1902. The bridge was dismantled shortly after the trolley was abandoned *c.* 1937.

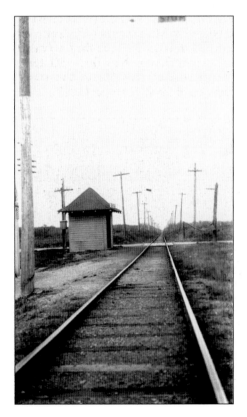

From 1902 to 1937, the Fast Line trolley traveled through South Brunswick Township and stopped at the small wooden stations located at Broadway, Friendship Road, Monmouth Junction, Dayton (shown here), and Davidson's Mill, as it traveled from Trenton to New Brunswick and back. This *c.* 1920 view shows the Fast Line as it traveled west from Trenton through Walter Applegate's farm (dividing it into two sections), crossed over Georges Road, and then traveled east between Daniel Sierco's farm (on the left) and Charles Richter's farm and continued on to New Brunswick.

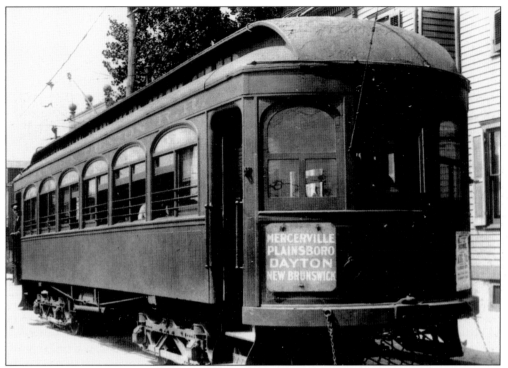

One of the original six trolley cars that operated on the Fast Line is shown in this *c.* 1912 view of Liberty Street in Trenton. Historian Robert Yuell provides a description of the cars as follows: "They were six large enclosed interurban cars form the Niles Car Manufacturing Company of Niles, Ohio. Four of these were regular passenger cars, Nos. 25 through 28. The other two were passenger-baggage cars, Nos. 10 and 11. The cars were lettered 'Trenton-New Brunswick Fast Line' when delivered. These cars were 45 feet long and had the names of towns along the route, as well as the number painted on them. The six cars were geared for 40 miles per hour."

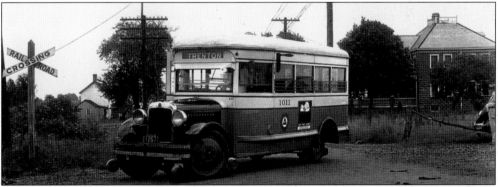

Pictured in 1935 is one of the gas-rail buses owned by the Public Service Rail Company and operated on a limited basis between Trenton and New Brunswick from November 1934 to May 1937. Built by Dodge Brothers, the buses were equipped with flange wheels, which allowed them to travel over the Fast Line tracks, and with regular tires, which allowed travel on the highways and roads. This photograph shows the No. 1011 bus turning onto Ridge Road and lowering the flange wheels to travel on the rails to New Brunswick. It looks like the driver forgot to change the destination sign.

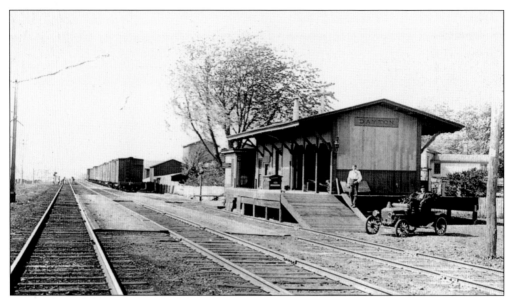

In 1865, the Freehold and Jamesburg Agricultural Railroad was extended from Jamesburg through the village of Crossroads (Dayton) to connect with the Pennsylvania Railroad in Monmouth Junction. There was opposition to the railroad being built at Crossroads (Dayton), based on safety issues and the need to move the schoolhouse. Once the issues were resolved, the railroad was allowed to come to the town. Shown here in this c. 1906 postcard view is a well-dressed woman awaiting the arrival of her train at the Dayton Depot. Decades later, the depot was sold and relocated.

In the 1830s, the New Jersey Railroad and Transportation Line built a spur that ended in the area now known as Deans. In 1839, a branch of the Camden and Amboy Railroad, which traveled between Trenton and New Brunswick, joined this spur. A depot was built off Beekman Lane (Major Road) a short distance from the McDowells' apple orchard. When the Pennsylvania Railroad assumed control, the railroad built a new station, which was named after the Dean family. Shown in this 1926 photograph is a Mr. Schmaltz standing near the Deans Railroad Station. Henry Werner was the ticket agent for the Deans Station.

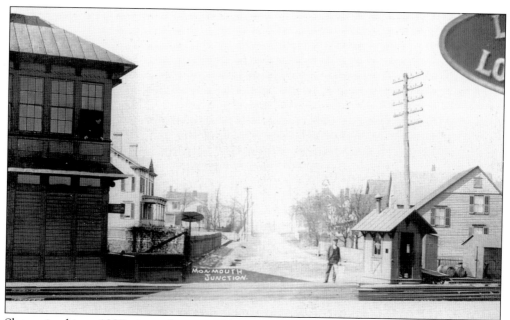

Shown in this *c.* 1907 postcard view is Alonzo Wright, a telegraph operator, in the window of the Pennsylvania Railroad tower located on East New Road. The East New Road railroad crossing was considered one of the most dangerous in the state and was eliminated in 1953, with construction of a new railroad bridge. The cost of the bridge, located off Ridge Road on East Road, was $158,000. Shown near the tower is the home of Theodore Stewart, which still remains in the Stewart family. On the opposite side of the street is the home of Antonio Santowasso, who ran a small grocery store from this building. It later became a tavern and was run by Santowasso's son, Anthony, until 1954.

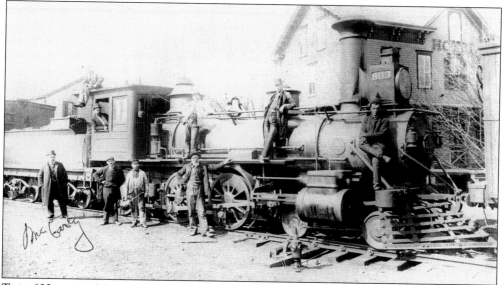

Train 603 stops at Monmouth Junction Station in 1910, long enough for the men of the railroad to take time out for a photograph. The train stopped next to the infamous Monmouth Junction Hotel, which was destroyed by fire *c.* 1917.

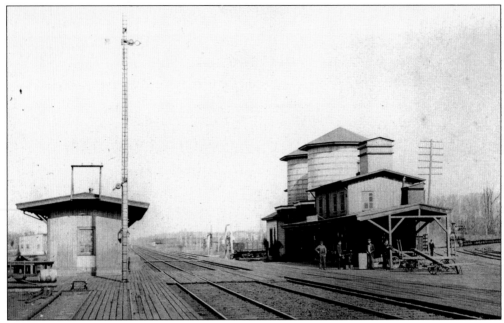

This 1867 photograph shows the first passenger station in the village of Monmouth Junction, which was built c. 1861. The railroad infused the community with a new vitality. The farmers could ship their produce to outside markets, and the railroad provided jobs and allowed the ordinary citizen to travel for the price of the ticket.

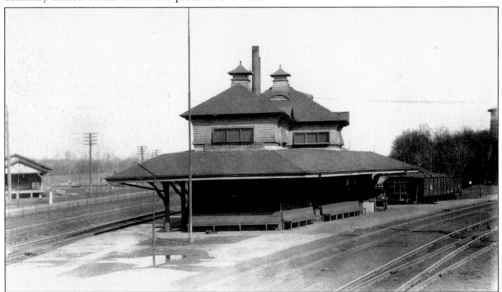

The village of Monmouth Junction was named because it was a junction for trains running to and from Monmouth County over a spur line built to connect with the Old Camden and Amboy Railroad and with the Jamesburg and Freehold Agricultural Railroad. The junction had become an important transfer point for seashore-bound passengers. Westbound trains discharged passengers, who then walked across the tracks and boarded the Long Branch train, eight to ten cars in length, which was headed for the shore. Shown here is Monmouth Junction's second railroad passenger station, built c. 1880 and demolished in the 1970s.

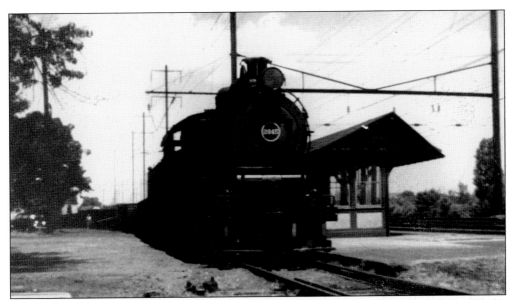

In his unpublished papers, Richard Stout wrote of a well-known train that traveled from Rocky Hill to Monmouth Junction Station around 8:00 every morning, and remained there until noon. Three additional cars were then added, and the train began its run to Jersey City. Every evening at 6:00, the train returned, slamming through Monmouth Junction Station at 60 miles an hour, with sparks flying from every shoe. It earned its reputation by capturing the record for the fastest run between Jersey City and Monmouth Junction, despite the fact that it stopped at every station along the line.

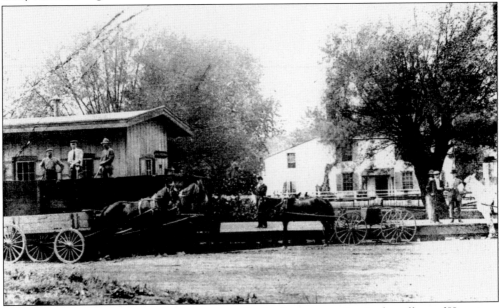

Shown in this c. 1900 postcard are various methods of transportation in the village of Kingston. A gentlemen stands near a horse and buggy, perhaps awaiting a passenger arriving on the Camden and Amboy Railroad. Near the railroad station is a team of horses hitched to a wagon, perhaps waiting to be loaded with supplies. The white house is where the lock tender for the Raritan and Delaware Canal resided. George Allen was the first lock tender for the canal.

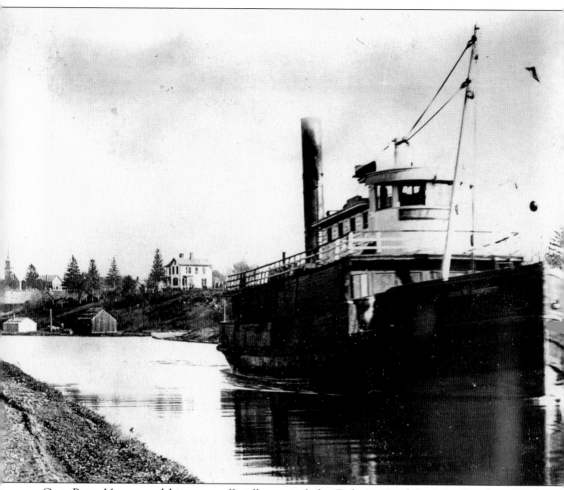

Gov. Peter Vroom and his party officially opened the Delaware and Raritan Canal in 1834 by traveling the 43-mile route by barge. They were greeted by jubilant onlookers, who stood in stark contrast to the thousands of laborers, mostly Irish immigrants, who performed the backbreaking, poorly paid work of digging the canal for three years. Many of the laborers died from cholera, which traveled through the labor camp. The intent of the canal was to provide a safe and short method of transporting commerce between Philadelphia and New York City. Railroads, however, cut heavily into the canal trade, leaving the waterway with less and less to carry. By the end of the 19th century, the canal had become ineffective as a cheap, quick method of transporting commerce, and it closed in 1933.

Five

EDUCATION

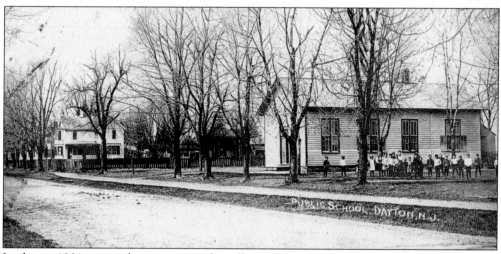

In this c. 1901 postcard view, we see the village of Crossroads's one-room house, which was built on the east side of Georges Road c. 1866. In 1865, the trustees for School District 11 paid Peter Rogers, a cobbler, $100 for the land. The one-room schoolhouse remained on the site until the two-room schoolhouse was completed. Then, in February 1907, the one-room school building was auctioned off. John Errickson, a local businessman who owned the Dayton Hay Press on Georges Road and Hay Press Road, purchased the one-room school and moved it to the hay press.

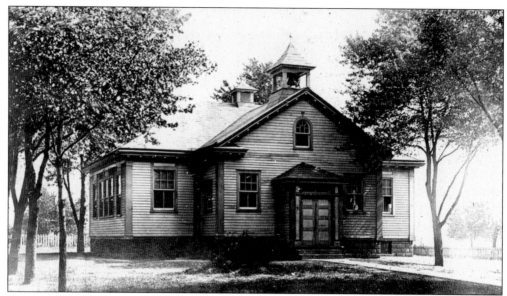

In 1905, a proposition to build a Dayton high school, a two-room schoolhouse with primary and grammar school classes, came before the town for the fourth time. For the fourth time, the proposition met with rejection by the voters, 195 votes to 92, even though the amount requested had been reduced from $5,000 to $3,000. The next year, however, through the efforts of the South Brunswick Board of Education, the building committee, and the taxpayers, the two-room school was completed for $3,700. This c. 1907 postcard view shows the attractive schoolhouse, located near the former one-room site.

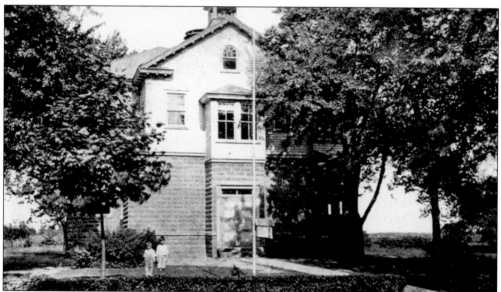

As school enrollment increased in Dayton, there was a need for additional classrooms. This was resolved by the South Brunswick Board of Education in 1911, by erecting a new concrete building and placing the wood frame school on top. While the work was in progress, the children from the upper classes were transported to Monmouth Junction School by a Mr. Dey, while the children from the lower classes walked a short distance north to Vanderveer Hall. This c. 1920 postcard view shows the attractive addition to the Dayton Public School.

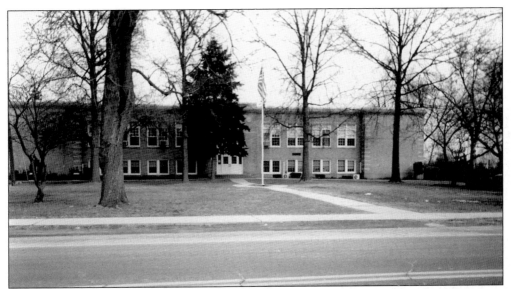

On March 3, 1928, John Griggs conveyed two acres of land near the Dayton Public School site to the South Brunswick Board of Education so a larger school could be built. When completed c. 1928, the Dayton School had eight classrooms, a cafeteria, a lunchroom, and a large auditorium, where graduation ceremonies could be held. In the past, the ceremonies had been held at the Dayton Presbyterian Chapel. Upon completion of the new school, the old Dayton Public School was demolished.

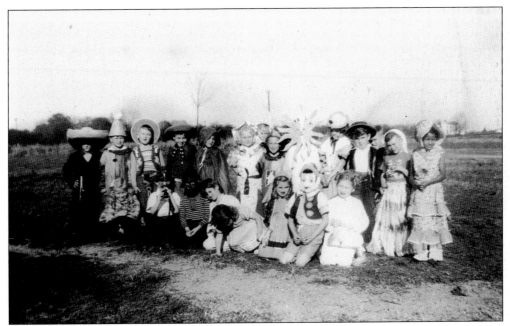

Florence Bowman's first-grade class is shown in October 1947, all dressed up for Halloween. Back then, each class at Dayton School had a party for Halloween. The children each selected a costume with which to surprise their classmates. Then, each class paraded in a circle in the auditorium, and different costumes were selected for prizes. An award was also given for the best-decorated pumpkin.

This page is from the "Book of Entry" that was kept by Jacob Rightmire for School Districts 7 and 4, and is dated April 21, 1839. The school district trustees at this time were Jacob Rightmire, John Messeroll, and John Hagaman. The last page of this book notes that, at a meeting held on April 7, 1856, the question of whether schools should be free or not was proposed. What these men believed is not known, since it was decided that they would discuss the issue at a future meeting. However, an answer came in 1871, when the legislature passed an act making the public schools of the state of New Jersey free.

The Sandy Run School was built prior to the American Revolution in Sandy Run (Deans). Due to the odd location of the school—in the center of the road, with traffic moving around it—a new school was erected on the east side of Georges Road before 1839. By 1872, this school was noted to be in poor condition. A vote was taken by the district on September 25, 1872, on whether to repair the school or build a new one on the old ground for no more than $1,000. The vote to build a new school was 14 to 11. The school district trustees were then given authority to borrow $900 and sell the old school.

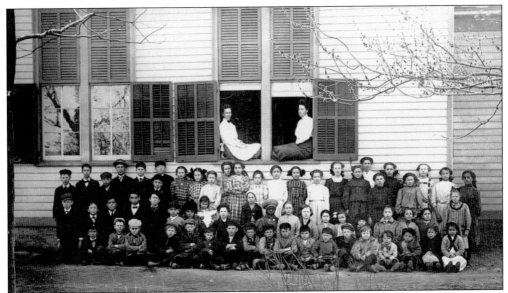

By 1907, there was a need for additional classroom space at the Georges Road School. George Waite of Deans conveyed property for this expansion, with the stipulation that if the property were used for any other purpose than a school, the property would revert back to the Waite family, which it did. A new Deans School was built in 1928. For a short time the old Georges Road School was used as a community center and, later, it was sold to Raymond Baker, who converted it into a residence. With their teachers behind them in the windows of the two-room school, students pose *c.* 1915 for their class picture. The building remains occupied today as a residence at the same location on Georges Road.

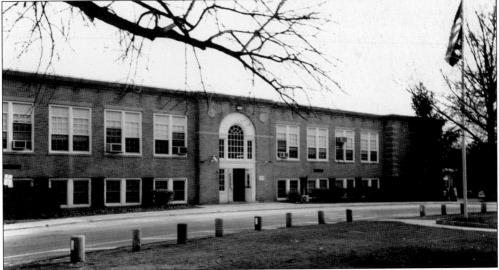

The Parent-Teacher Association was established in 1927 in Deans, and it successfully petitioned the South Brunswick Board of Education for a new school. A special vote was held, and the outcome favored a new school. Through the efforts of the Parent-Teacher Association, the school was built in 1928. Deans School had eight classrooms, a large auditorium, electricity, running water, and indoor plumbing. Elsie Weber, president of the Parent-Teacher Association, stated that it was a dream come true.

The dedication of Deans School was held on February 14, 1929. John Salaki, the builder, presented the school key to Welsey McDowell, vice president of the South Brunswick Board of Education. Harriet Pinter, the principal, assured everyone that she would carry out the responsibility placed upon her. Floyd Evans, supervising principal, ended the evening with a special tribute to Mary Schuh of Deans, for organizing the dedication program.

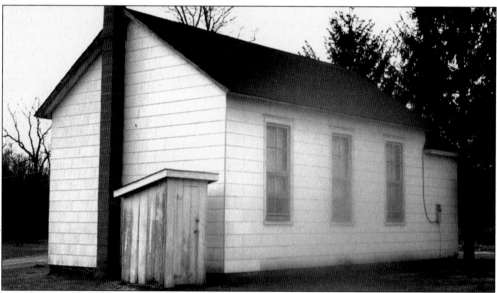

On March 1834, Catherine Rue deeded an acre of land to James Combs and the other school district trustees for 50¢ to build a schoolhouse in Woodsville (Fresh Ponds), near the intersection of Davidson's Mill and Fresh Ponds Roads, where a one-room schoolhouse stands today. The Fresh Ponds School of 1869 was not a free school, and the tuition collected that year was $102.22. There were 37 students enrolled on the school register, with an average attendance of 18. The school closed c. 1930 and is now owned by the American Rescue Mission, under the auspices of Rev. Robert Turton III.

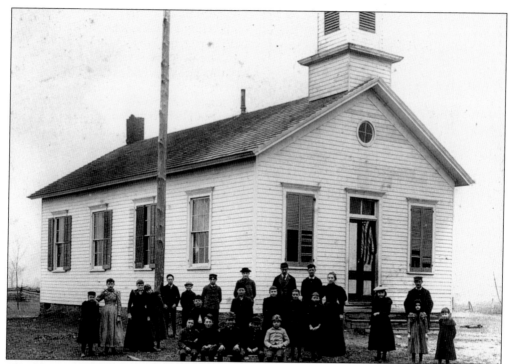

The Rhode Hall School was described in 1869 as being in poor condition. In 1871, Francis Farr conveyed an acre of land for a new school to be built on the west side of Laurie Road (Cranbury-South River Road), near Monroe. The Rhode Hall School, shown here *c.* 1894, received students from both Monroe and South Brunswick until it closed in 1929. The South Brunswick Board of Education sold the building, and it was used as a community center before it was eventually demolished.

The one-room schoolhouse known as Pleasant Hill was built before 1850 on Laurie Road (Cranbury-South River Road). In 1879, the school, which had been built to seat 40 students comfortably, was described as being in poor condition. Evidently there was never enough money available to make the necessary repairs. Lenora Applegate Ely taught at Pleasant Hill from 1903 to 1912.

Pictured here *c.* 1895 is the one-room school house that was built *c.* 1835 on the Stout farm (Johnson Plantation), which stood on the southeast side of Ridge Road. In 1869, there were 60 students on the school register and the tuition collected came to $75. When the Ridge School closed in 1913, the property reverted back to the Stout family, who converted the building into a tenant residence. In 1928, John Vagi purchased the building and moved it to its present location, on Perrine Road.

In 1913, Culver Beekman conveyed land on the corner of Ridge and Perrine Roads to the South Brunswick Board of Education for a new schoolhouse. Gertrude Murrman was the first to teach at the new Ridge School when it opened in September 1913. Dwindling enrollment and school centralization were factors in the school's closing in 1930, and the remaining 20 students were sent to other schools. The Ridge School, shown here *c.* 1929, was sold in 1931 to George Perrine, who converted it into a residence. The building, unoccupied today, still stands.

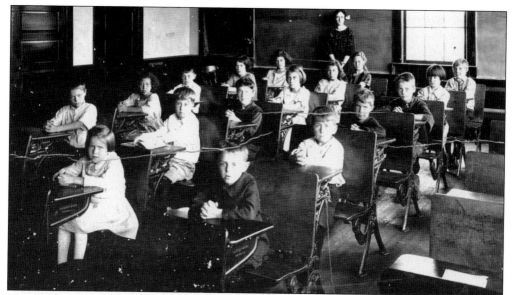

The Ridge School had one classroom, shown here *c.* 1920. Local historian Katherine Clayton described the interior as having a tin ceiling and four rows of desks. The desk-seat combinations were graduated in size, with the small ones across the front, and larger sizes in the back of the room. Both Ridge schools lacked wells, and it was necessary for the children to make daily trips to Mrs. Deal Brewer's well for drinking water.

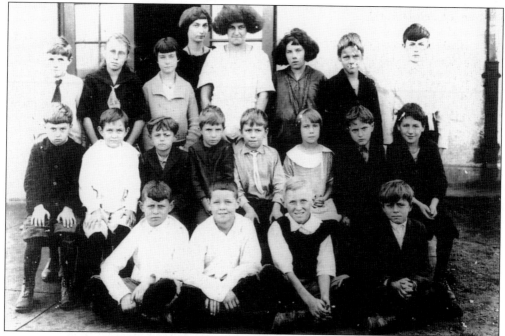

Pictured in 1923, the Ridge School students and their teacher are, from left to right, as follows: (first row) Elwood Landis, John Kelly, Franklin Mershon, and Frank Poandl; (second row) John Bobko, William Mershon, Steve Poandl, Walter Schenck, Earl Mershon, Katherine Kenny, Theodore Stoller, and Earl Renk; (third row) George Schenck, Mary Schenck, Margaret Green, Mabel Volk (teacher), Mildred Landis, Margaret Kelly, Edgar Renk, and Edmond Green.

Addie Chamberlain of Netcong, photographed here in 1927, taught at the Ridge School from September 1925 to June 1927.

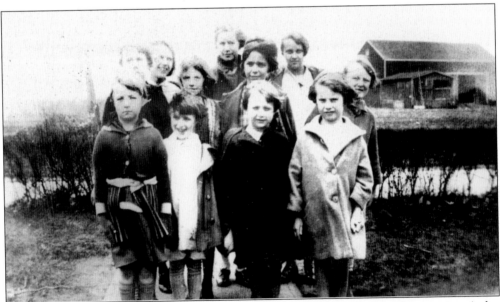

The girls of Addie Chamberlain's class stand for their school picture on a breezy winter's day in 1927. From left to right are the following: (first row) Marion Kronnagel, Anna Kenny, Virginia Landis, and Ruth Stout; (second row) Katherine Kenny, unidentified, Mildred Seitz, and Marion Stout; (third row) Bessie Krebs, Florence Seitz, and Erma Landis.

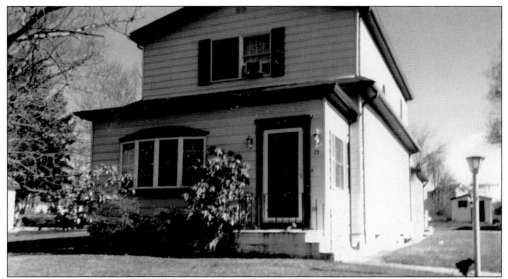

In 1889, the Farmer family sold an acre of land on Old Ridge Road, a short distance from the village of Monmouth Junction, to the trustees of School District 77 for $250. The one-room schoolhouse was built by Magee and Davison of Jamesburg for $850 and opened on January 1889 with 30 students. The school closed in 1902, and in 1903, Gerhard Bauman purchased the building and converted it into a residence.

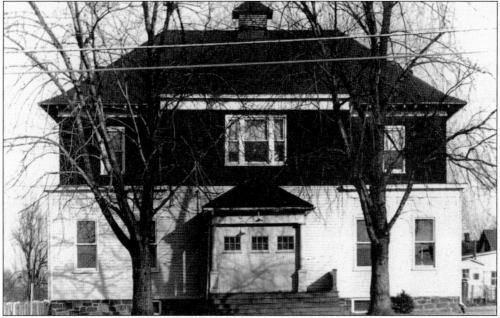

On December 30, 1901, the South Brunswick Board of Education paid the Rowland family $300 for a lot on New Road in Monmouth Junction for a new school. The two-story Monmouth Junction School opened in 1902, with two classrooms and 44 students. In September 1911, contractor Louis Bower of Dutch Neck completed the second-floor classrooms for $1,000. The school was closed in 1951, when a new school was completed. The old building was then used for a number of purposes, including a courthouse. It was then used by the first aid squad, which demolished the building c. 1975 to make way for a new building.

Monmouth Junction Grammar School students pose with their teacher *c.* 1903. From left to right are the following: (first row) Mabel Collins and Julia Cahill; (second row) Charles Gottiaux, John Grace, teacher Emma Morton (Rowland), Peter Emens, and Russell Carlisle; (third row) Cleveland Landis, Frank Morrisey, Ethel Mershon, Frances Stryker, Jacob Groendyke, and Ella Paradine; (fourth row) Florence Collins, Edna Wright, Lily Griggs, Nellie Emens, Annette Stryker, and Will Stout.

On a warm summer day *c.* 1928, Theresa Scurato (Kish) (second row, third from the left) stands with her fellow classmates and teacher at the Monmouth Junction School on West New Road.

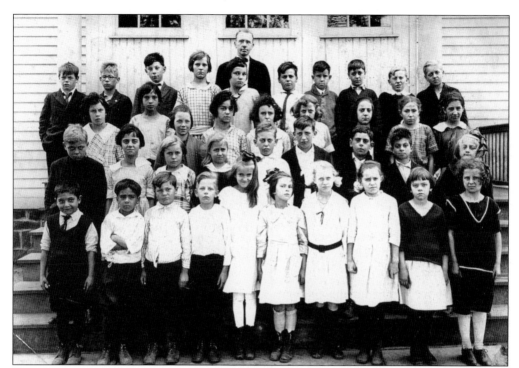

Shown in this *c*. 1927 photograph are the students of Monmouth Junction Public School, located on West New Road.

The seventh- and eighth-grade students of Monmouth Junction School smile here for their 1937 class picture. From left to right are the following: (bottom row) Betty Gottiaux, Doris Daust, Dolly Cicchino, and Mabel Breese; (second row) Eleanor Carlisle, Marion Gottiaux, Edith Anderson, and Dorothy Zwonetschek; (third row) Margaret Mihaljko, Betty Breese, Joyce Donney, and Charles Isak; (top row) Gloria Bonner, Serafina Cicchino, Thomas Scurato, and Walter Kozacheck.

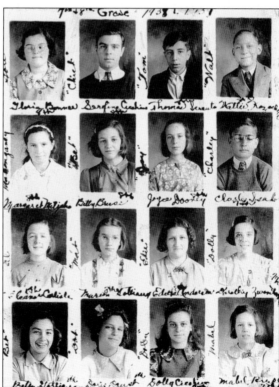

At 8:00 p.m. on June 12, 1936, the graduation exercises for the class of 1936 were held at Mechanics Hall on Ridge Road. Betty Brabson performed musical selections on the piano, and John Sierco played the violin. Crawford Robertson greeted everyone, and the graduates' presentations on communications followed. G. Edward Holloway, supervising principal, awarded the eighth-grade certificates. The evening ended with the graduates and audience singing "Auld Lang Syne," and with a benediction given by Rev. A. Raymond Eckels.

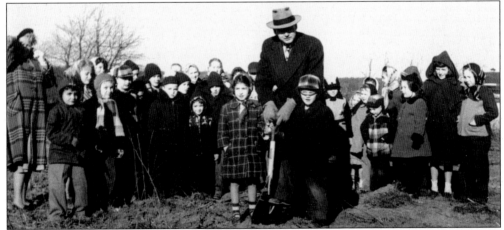

Judge William Grant Schonely, president of the South Brunswick Board of Education, proudly overturns the first shovel of dirt at the groundbreaking ceremony for the new Monmouth Junction Elementary School, held on November 22, 1949. The children appear to be delighted to be part of this event.

Sand Hills School was built before 1850 on Major Road, a short distance from the Straight Turnpike (Route 1), and was the first school in South Brunswick Township to have a library. In 1869, the school, which was free, was described as being in fair condition. There were 82 children of school age in the district, with an average attendance of 26. Pictured standing outside the school *c.* 1920 are Emma and Greta Bellizio. In 1944, the board of education sold the property to Harry Walker, who converted the building into its present use as a residence.

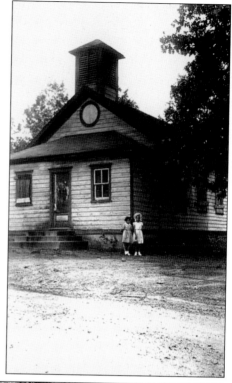

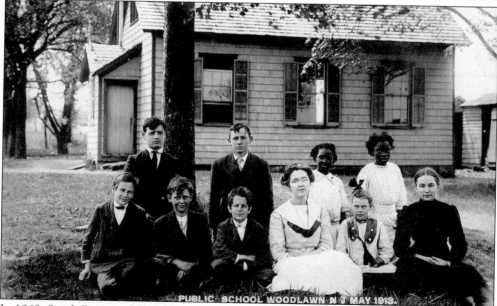

In 1869, South Brunswick had 18 school districts and not all the schools were located in South Brunswick Township. The Ten Mile Run Schoolhouse was built *c.* 1700 in Franklin Township. Located on Old Stage Road (Route 27) near Bunker Hill Road, it received students from South Brunswick. In 1891, a new school was erected on the old site. Photographed here in 1913 is Eva Smith (Beekman) of Kingston with her class. On her left is Helen Beekman of South Brunswick. The school was abandoned in 1922 and was sold in 1924 for $1,000.

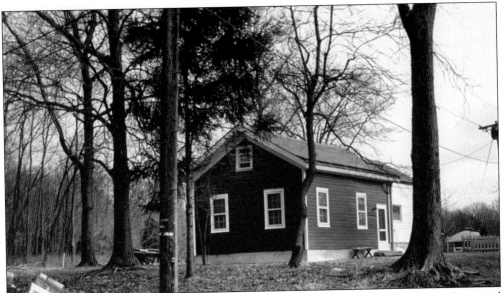

The Little Rocky Hill one-room schoolhouse was built on the corner of Schoolhouse Lane and Old Stage Road before 1850. In 1869, the school register showed 37 students enrolled, with an average attendance of 16. In 1909, the school closed and a school stagecoach run by John Ruse transferred the students to Kingston School. The school reopened in 1914, only to close again in 1918. The building was eventually sold and converted into a residence, as shown in this 1975 photograph.

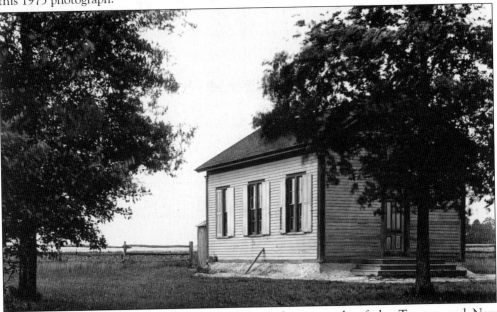

The Mapleton School was built before 1850 on the west side of the Trenton and New Brunswick Turnpike (Route 1). It was located in the Mapleton section of South Brunswick, which became part of Plainsboro Township in 1919. Mapleton was not a free school. In 1869, there were 60 children of school age in the district, with an average attendance of 20. When the school closed, the South Brunswick Board of Education conveyed the property by quitclaim to Elston Hawk for $30 on May 19, 1911.

Shown here is Kingston Grammar School, built on the corner of Academy Street and the Kingston and Princeton Turnpike (Route 27) in 1871. The schoolhouse is now a privately owned office building.

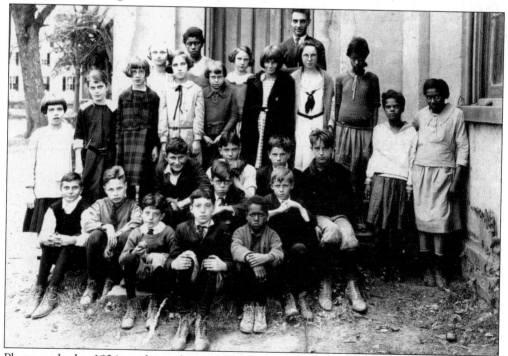

Photographed c. 1924 are the students of Kingston Grammar School. From left to right are the following: (first row) Theodore Catelli, Joseph Catelli, and Raymond Burnett; (second row) Eric Zaph, Roland Teamer, Earl Snedeker, and Howard Snedeker; (third row) Matt Feldman, Peter Van Note, unidentified, and Chester Potts; (fourth row), Margaret Kaltschmid, Grace Barlow, Bernice Teamer, Jessie Anderson, Dorothy Heath, Audrey Langer, Nelly Meyers, Ada Burnett, Hazel Lewis, and Mildred Randolph, (fifth row) Hazel Updike, unidentified, and Elizabeth Van Note; (sixth row) Forrest Richards (teacher).

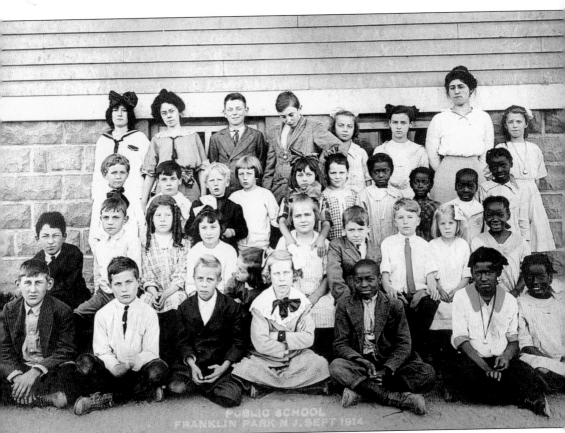

The one-room Six Mile Run schoolhouse, built before 1850, was located on Route 27, a short distance north of Henderson Road, in South Brunswick. In 1908, the school was closed and the property was sold to Henry Ohlman for $25. The school had received students from South Brunswick (Middlesex County) and Somerset County. The children from South Brunswick were transferred to the new Franklin Park School, located in Somerset County. Among those pictured in this Franklin Park class photograph of 1914 is Elmer Beekman (second row, second from the left).

Six

CHURCHES AND CEMETERIES

Built in 1840 on land conveyed by Catherine Rue, the Fresh Pond Chapel is one of the oldest church buildings still in use in South Brunswick Township. Originally it was a Methodist Episcopal church and in 1853, it became a Methodist Protestant church (without bishops), at which time the church building was also known as the Ebenezer Meeting House. Since 1887, the Fresh Pond Chapel has been nondenominational. It is now owned by the American Rescue Workers and is in the process of being restored.

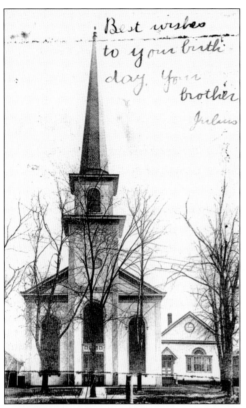

On October 5, 1869, Richard McDowell and Thomas Schenck were sent to a meeting of the presbytery to petition for organizing a Presbyterian church in the village of Dayton. A committee of the presbytery came to Dayton on October 16, 1869, and the church was organized. The new church had 57 members from seven different denominations. The total cost of the lot, church, and furniture was $10,390. The Dayton Presbyterian Church, located on the east side of Georges Road, was dedicated on August 31, 1870, and Rev. Joseph Hubbard was installed as the first pastor in November 1870.

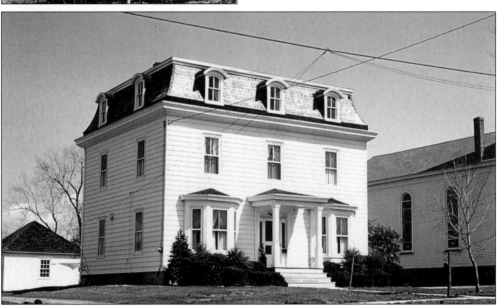

On the day that the Dayton Presbyterian Church was dedicated, a subscription was taken to raise funds for the construction of the parsonage. At a meeting three days later, it was decided to purchase a second lot from Samuel Pullen for the parsonage. The total cost of the lot, barn, and parsonage was $4,128. In 1902, during Rev. James Clark's pastorate, electric lights and stream heat were installed in the manse, shown here c. 1975, and in the church.

On December 6, 1876, the ladies of the Dayton Presbyterian Church formed a "sinking fund association," whose objective was to eliminate the debt on the church property. In 1880, Rev. Samuel Rowland divided the church into 16 groups and apportioned the debt among them. Subscriptions were to be made on the condition that the whole debt would be removed by October 1881. Shown here is the subscription of Henry McDonald, who contributed $40. The debt was retired through the efforts of the fund and Reverend Rowland.

The St. Mary's Mission was formed by Rev. Charles Butler on December 1958 in the village of Cranbury. The small group found a home on Dey Road, only to be displaced by fire. John Barclay offered the congregation an acre of land on Broadway Road in South Brunswick, with the stipulation that services were to be held for 100 years or the sale would be revoked. The congregation accepted, and in 1966, St. Mary's Primitive Baptist Church was built. In 1980, it was renamed the St. Mary's Missionary Baptist Church.

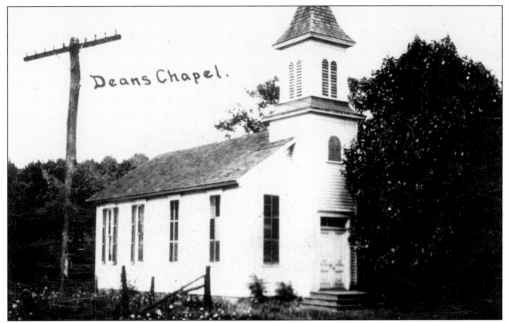

The Deans Sunday School Association was organized at a meeting held in 1884 at the Georges Road School in Deans. George "Squire" McDowell was elected president. In 1885, Joseph Case donated land on the west side of Georges Road in Deans, where the chapel was erected and furnished for $1,026. Shown here abandoned c. 1930, the chapel was sold in 1941 for $250 to Harold Errickson, who converted it into a residence. The property was sold and the building demolished c. 1998.

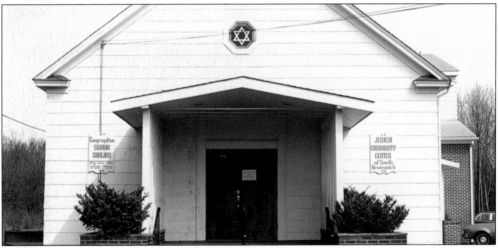

In 1941, a group of Jewish poultry farmers organized South Brunswick's first synagogue and Jewish farmers' community center, Congregation Sharri Sholom, shown here in 1975. The building that housed the center was located east of Route 130 and north of Deans on Old Georges Road and was built in 1942 with recycled lumber from a dismantled New York City train station. As demographics changed, there was a need for a larger center, and Congregation Sharri Sholom became part of Congregation B'nai Tikvah, located in North Brunswick. The Sharri Sholom building was sold to the Loyal Order of Moose Brunswick 263, the present occupant of the building.

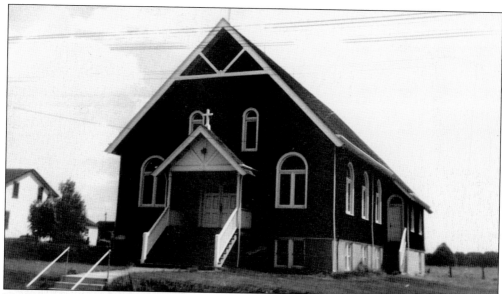

In 1911, before St. Cecilia's Roman Catholic Church building was constructed in Monmouth Junction, the first Mass was conducted by Father Quinn from St. Joseph's Parish of Millstone. It was held in the home of Serafino Notti, on Ridge Road, where the present South Brunswick Municipal Building now stands. Michael Cahill conveyed land to the Trenton Diocese for the new church and allowed the congregation to hold services in his barn until the new church on Old Ridge Road was completed.

The stone used for the foundation of St. Cecilia's was carried in from the surrounding fields. Arthur Turton of Monmouth Junction was given the contract to build the church for $6,728, and he completed it in 1914. This small church was the scene of many happy occasions, including the wedding of Theresa Scurato and Alex Kish in 1945. When a new church was erected on the corner of Kingston Lane and Georges Road, the 1914 church, with its simplistic beauty and warmth, was sold to a developer and demolished.

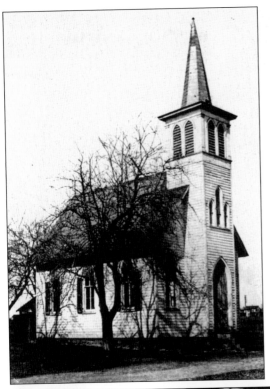

The Methodist church was built by James Hunt, a local farmer, c. 1877 on East New Road in Monmouth Junction. In 1883, Rev. John Miller of Princeton began holding services in this small church and then purchased the building for $485. The name was changed to the Cumberland Presbyterian Church of Monmouth Junction. In 1907, the church was received by the Presbytery of New Brunswick and became the First Presbyterian Church of Monmouth Junction. The church building was later sold and converted to a residence, its present use.

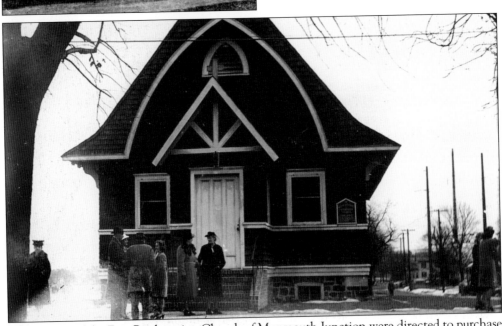

The trustees of the First Presbyterian Church of Monmouth Junction were directed to purchase the former St. Paul's Episcopal Church building, shown in this c. 1915 postcard view. The church building was purchased for $1,000 and renovated. Located on the corner of East New Road (Pierson Street) and Ridge Road, the church was renamed the Miller Memorial Presbyterian Church of Monmouth Junction in recognition of the work of Rev. John Miller and his family.

Rev. Alfred Baker, rector of the Trinity Church of Princeton, held services in the Sand Hills School House in 1871. In 1872, the Long family of Sands Hills donated land to the trustees of the Episcopal Fund of the Diocese of New Jersey for a church. The congregation erected the church on Major Road near the Straight Turnpike (Route 1) in Sands Hills. The cornerstone for St. Barnabas Church was laid in 1872. Here, Howard Bellizio stands on the church steps c. 1940. He later served as an acolyte.

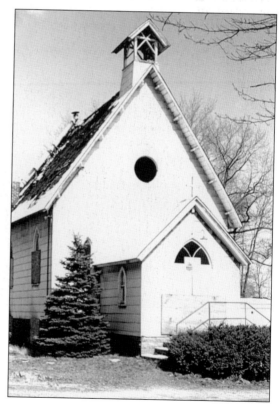

In 1965, as the St. Barnabas congregation increased, the church reached a difficult decision to hold services at the Greenbrook Elementary School in Kendall Park until a new church was built. The diminutive church, shown here c. 1975, stood stoically until a fire, which did extensive damage to the interior, decided the building's future and it was demolished. The stained-glass window was removed and placed in the new church, built c. 1970, on Sand Hills Road.

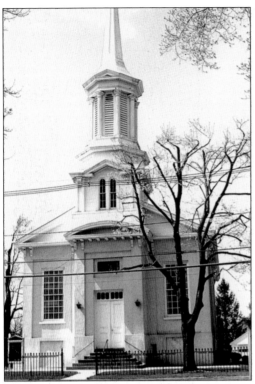

The original site of the Kingston Presbyterian Church, established in 1723, was on the east side of the cemetery near the Millstone River. During its existence, the church welcomed the itinerant preacher David Brainard, who had been expelled from Yale for saying that one of his tutors "had no more grace than this chair." In 1791, a fire destroyed the original log church and in 1792, a new church was built on the old foundation. The present Kingston Presbyterian Church was built in 1852 and stands on Main Street in Kingston, in Somerset County.

St. Augustine of Canterbury Church was built in 1951 on Henderson Road by the Trenton Diocese to provide the Catholics of the Franklin Park area (now Kendall Park) with a permanent place to conduct religious services. Rev. John Reilly was the first to serve and did so from 1958 until 1978. As the congregation increased, a new church was needed, and one was built in 1989. The original church (pictured), often referred to as "the Little Church," was demolished. There is also a school on this site.

The First Six Mile Run Reformed Church was built in 1766 in the village of Six Mile Run, located in Somerset County. The church was dismantled in 1816 in order to build a new church. In 1879, the Six Mile Run Reformed Church was destroyed by fire and replaced by the Gothic-style structure that now stands on the site. The Frelinghuysen Memorial Chapel, shown here c. 1911, was built in 1907 and dedicated the following year.

Shown in this photograph is a copy of the original diagram of the Six Mile Run Reformed Church pews. In 1879, the church sold pews to members in order help pay for the costs of the new church. The pews in the front had a greater value than the ones in the back, and the pews under the balcony had even less value. The church pews were in demand; Peter Cortelyou of South Brunswick paid $190 to rent his pew, No. 34.

On April 27, 1848, William and Harriet Jones conveyed land on the west side of Georges Road in the village of Crossroads (Dayton) to the trustees of the Baptist Religious Society of Crossroads for a church and cemetery. The oldest legible gravestone is that of John T., son of Samuel and Mary Ann Disbrow, who died on February 28, 1854. The Dayton Cemetery, shown here c. 1915, is run by the Dayton Cemetery Association.

The Dean family cemetery, located a short distance from Major Road, may have been established in 1783 with the death of Andrew, the two-year-old son of Abraham and Isabel Dean. When Aaron Dean exempted the half-acre cemetery from an 1821 land transfer to his sister, his intent was for the property to remain a Dean family cemetery. The last Dean to be buried there was his wife, Ruth Dean, in 1916. Members of Stewart family are also buried there.

The Fresh Ponds Cemetery was established *c.* 1840 by the Methodist Episcopal church on land conveyed by Catherine Rue in Woodsville (Fresh Ponds). Here, the resting places of the old families of the Fresh Ponds area are surrounded by a delicate old wrought iron fence and towering trees. Civil War veterans who lie at rest here include William Mulvey, who enrolled in Company H of the 1st Regiment and died on July 6, 1862, and Charles Benson, who enlisted with Company A of the 34th New Jersey Infantry as a private and returned as a corporal. Benson died on July 2, 1904.

The oldest legible headstone in the Fresh Ponds Cemetery is that of Sarah Blew, who died in 1843, and whose inscription reads, "she was a tender mother."

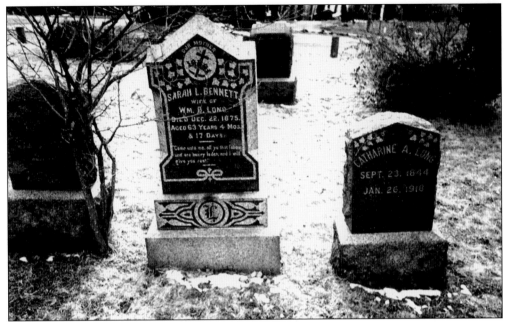

The St. Barnabas Cemetery is located on Major Road, in close proximity to Route 1, and was established when the church of the same name was built on land donated by the Long family. Members of the Long family are buried here, along with Civil War veteran Rueben M. Breese of Company I of the 28th Regiment New Jersey Volunteers, who died in 1881.

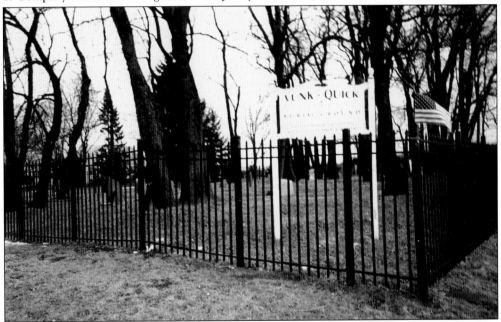

The Vunk-Quick Cemetery is located on the southwest side of Beekman Road, less than a half a mile from the intersection of Route 27. Col. Abraham Quick, who fought in the American Revolution, is buried here. Quick resigned his commission on September 9, 1777, and died on May 25, 1805, at the age of 73. Only a few feet away lies Pvt. Peter Kinney, who served under Quick during the American Revolution.

Seven

RESIDENTS

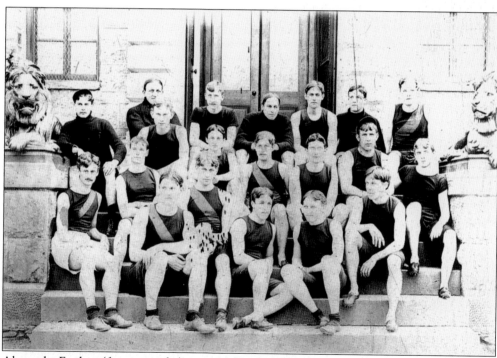

Alexander Fordyce (first row, right) is pictured with the track team outside Clio Hall at Princeton University in 1894. He was born in New York City on February 13, 1871, and moved with his family to a farm on Georges Road outside the village of Dayton. His education was provided by private tutors and private schools. He graduated from Princeton in 1896, received his law degree from New York City Law School in 1898, and then established his law practice in New York City. After his marriage to Ida McCoy, Fordyce resided in North Jersey. He was elected to the New Jersey Assembly in 1902 and again in 1905. Gov. Woodrow Wilson appointed Fordyce president of the Civil Service Commission, a position he held from 1912 to 1916. Fordyce died in 1959 at the age of 88, four years after retiring from his New York law firm.

William Lewis Dayton was born on February 17, 1807, to Joel and Nancy (Lewis) Dayton of Basking Ridge. Dayton graduated from Princeton University in 1825. He served as a state senator from 1842 to 1851 and also as a Supreme Court justice, a state attorney general, a vice-presidential nominee (1856), and a minister to France from 1861 until his death in 1864. Abraham Lincoln said of Dayton, "there is no man for [whose] character I have more admiration." The village of Dayton is believed to have been named for this distinguished citizen of 19th-century New Jersey.

Wabun Krueger, an agricultural engineer for the New Jersey College of Agriculture at Rutgers University, resided in the Applegate House, located on the west side of Georges Road in Dayton. In 1929, Hiram Deats donated a plow invented by his grandfather to Rutgers University in the hope that this would encourage further collecting and would be the basis for a museum. Krueger made Deats's hope a reality. Over the next 40 years, Krueger collected over 3,500 agricultural and related objects on behalf of Rutgers University. The Krueger collection was the catalyst for establishing the New Jersey Museum of Agriculture, which tells the story of New Jersey's agricultural past, present, and future.

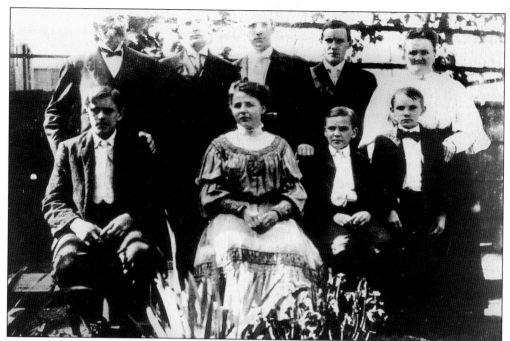

This early-1900s photograph shows members of the Noebels family. From left to right are the following: (first row) Gerhardt, born in 1891; Mary, born in 1889; Joseph, born in 1895; and Rudolph, born in 1879; (second row) Carl Noebels, the father; Albert, born in 1884; Henry, born in 1882; Charles, born in 1886; and Anna Noebels, the mother. Gerhardt and Joseph Noebels lived in Dayton and owned properties in South Brunswick.

Annabel Perrine (Havens) (left) stands next to her only sibling, Violet, and her mother, Mildred Perrine, in 1909. The house where she was born and lived until her death at 93 now stands empty and boarded up on Highway 130.

Daniel and Adeline Rizzlo Sierco, shown here in 1917, owned a farm on Georges Road and a home on Ridge Road in Monmouth Junction, now the site of a bank. The home was destroyed by fire in the 1940s. Sierco owned a number of businesses in North Jersey and often worked on the farm, adding to the apple and peach orchards and planting trees that still remain today.

Marie Sierco, the daughter of Adeline and Daniel Sierco, is pictured at age three in 1921. She and her brother, John Sierco, graduated from Monmouth Junction Grammar School in the 1930s. After marrying Dominick Guerriero, Marie moved to the farm in Dayton, which she eventually inherited from her parents, and raised her three children, Daniel, Doris, and Maria, there. It was a wonderful place to grow up.

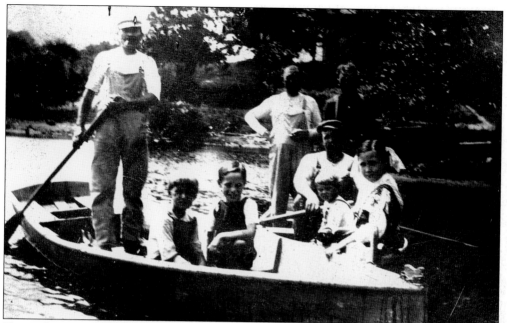

Shown here *c.* 1915 is a group of happy rowers and children about to embark on a little excursion on the millpond off Riva Avenue. The Werner family named the millpond Werner Lake. Clara and Henry Werner, owners of the gristmill, and their two sons, Frederick and Henry Jr., rented out rowboats for a nominal fee.

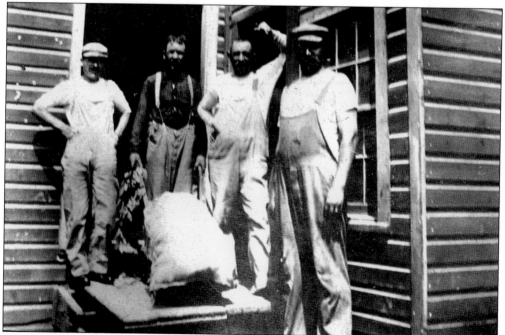

Shown here *c.* 1910 are workers standing on the stoop of the old clapboard three-story Werner gristmill (formerly Davidson's Mills), located off Riva Avenue. When Henry Werner Sr., owner of the mill, delivered flour by horse and wagon to the bakery in South River, approximately 60 miles round-trip, it became an all-day delivery.

Wearing summery white dresses and fanciful hats, three young women of Monmouth Junction—from left to right, Bertha Griggson, Lily Griggs, and Elizabeth Stewart—enjoy a day at the beach. The beach was accessible for those who lived in South Brunswick, since all one had to do was buy a train ticket at the Monmouth Junction Railroad Station and take a scenic ride to the New Jersey shore.

Standing near her barn door in the 1930s, Cornelia "Neely" Bossomberry holds the hand of her great-granddaughter, Joan Olson (Kish). Neely and her husband, Luther Bossomberry, owned a farm on East New Road in Monmouth Junction. She was an ambitious person who traveled alone by horse and wagon to New Brunswick to sell her fresh vegetables. In 1924, her husband purchased the old Hathaway building off Maple Street in Monmouth Junction, where she ran a candy-and-ice-cream store and pool hall. The Bossomberry farmhouse was destroyed by a fire that is believed to have been the result of sparks flying from a passing train.

Anthony Spilatore of Sand Hills operated a cider mill with his wife, Rose, near the family home, located on the north side of the Straight Turnpike (Route 1). He arranged social events that included hayrides and box socials, complete with fiddlers, which were enjoyed by the students of Princeton University. Spilatore worked on the railroad and, at the age of 38, was killed when he was crushed between two passenger cars. This photograph dates from 1890.

Rose Spilatore (left) and her daughter, Belle, beautifully dressed c. 1918, pause in the middle of a dirt road, referred to as the Straight Turnpike (Route 1). Belle Spilatore was born a short distance away in the family home on February 14, 1894. In the background are the hills that were later removed through excavation. The soil was sold off to individuals and developers.

Eva Smith of Kingston taught at the Woodlawn School at Ten Mile Run in Somerset County. During the week, she boarded at the home of a local farmer, where she was told that if she placed a wishbone over the front door of the farmhouse, the first man to enter would be the one whom she would marry. Unbeknownst to her, only Ralph Beekman entered through the front door of the house. She and Beekman were married on May 21, 1917. This photograph was taken in 1912.

Sitting together c. 1910 are members of Eva Smith's family, from left to right, George and Mary Smith and their sons, Frank and George Smith.

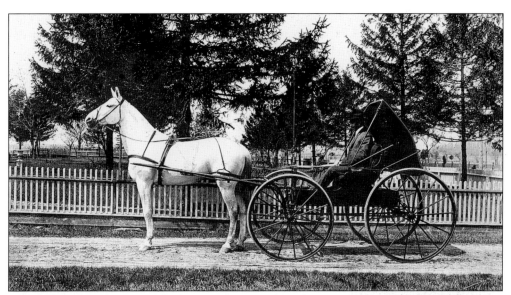

The Beekmans' ancestors, Wilhelmus Beekman and family, came to America in 1647. They had been residents of the country of Rhine, and some family members were Belgian barons. The Beekmans settled throughout New York and New Jersey. William Beekman built the Beekman Homestead in New Amsterdam, near the present corner of Pearl and Beekman Streets, in 1670. The Beekmans of South Brunswick owned farms and pursued their interest in horse racing. Pictured c. 1900, are Ralph Beekman and his trotter, John Sprague. One of the places where Beekman and John Sprague raced was on Livingston Avenue in New Brunswick. Beekman Road was named after the family.

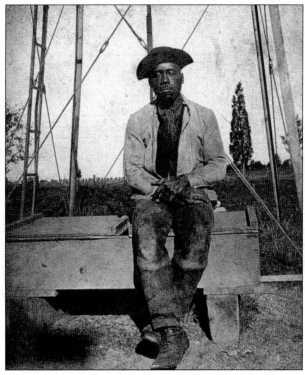

Charles Robbins worked for Ralph Beekman on his farm and later worked for the son, Elmer Beekman.

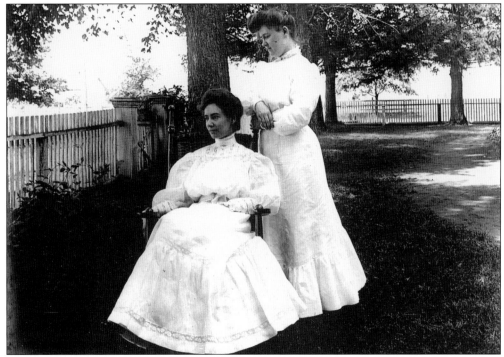

The daughters of Theodore Williamson of Franklin Park strike a pose for photographer Martin Garretson on July 4, 1905. On what appears to be a warm summer day, Mary Williamson sits gazing beyond the white picket fence, while Grace Williamson stands behind her.

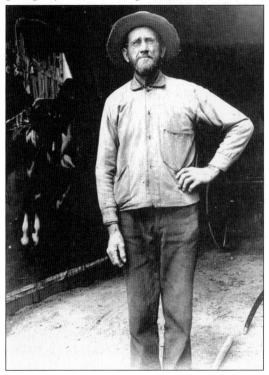

A short distance from Theodore Williamson's house was the home of Isaac Williamson, who willingly poses for the camera on April 22, 1904. Isaac Williamson lived across the street from the Six Mile Run Reformed Church, in Franklin Park, on the South Brunswick side of the village. The house has since been demolished.

Eight

SERVING THE COMMUNITY

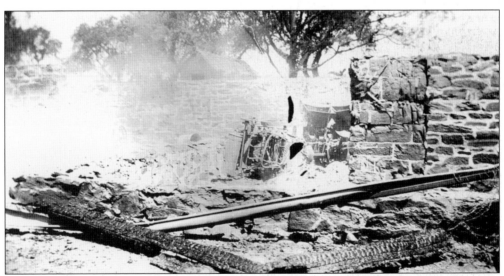

Pictured are the remains of a barn owned by Raymond Anderson of Monmouth Junction that was destroyed by fire. During the regular meeting of the Monmouth Junction Red Sox baseball team on August 8, 1924, there was a discussion on a number of serious fires that had taken place in the last two years and the need to establish a fire company. J. J. Ryan, president of the Red Sox, dedicated the meeting of the following week to this purpose, and it was then decided to call the townspeople together at Al Lewis's movie theater to establish a fire company. The 34 men who attended the August 24, 1924, meeting became charter members of the newly formed Monmouth Junction Volunteer Fire Department.

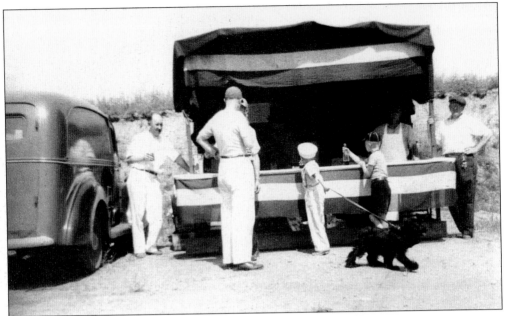

The Monmouth Junction Volunteer Fire Department began without money, equipment, or property. A decision was reached at the August 24, 1924, meeting to hold a three-day carnival in September to raise money. The carnival was held on Ridge Road in what was then called the gravel pit. It raised $2,400 and became an event that was held annually for the next 20 years.

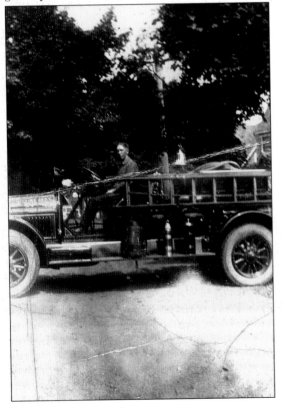

In 1925, the trustees of the Monmouth Junction Volunteer Fire Department entered into an agreement with the American LaFrance Company for a 1925 Brockway soda-and-acid fire truck at a cost of $3,850. The truck is shown here in 1925. According to local historian Roger Potts in *The History of the Monmouth Junction Volunteer Fire Department*, the truck was used for a fire on the very day it was delivered—January 20, 1925. For $8 per month, the truck was housed in a Walnut Avenue garage, which still stands today.

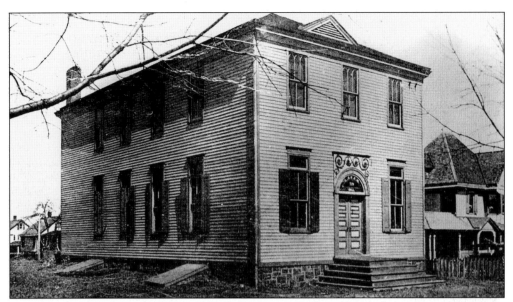

In 1900, the Royal Council No. 139 of the Junior Order of United American Mechanics purchased property located on the north side of Ridge Road in Monmouth Junction from the Rowland family and built Mechanics Hall. A grand ball, chaired by Alonzo Wright, was held in 1901 to officially open the entertainment hall. Many social functions were held at the hall, including the successful and profitable performances of the Monmouth Junction Dramatic Club, featuring local talent. In 1946, Michael Fenske purchased the building and converted it into three apartments.

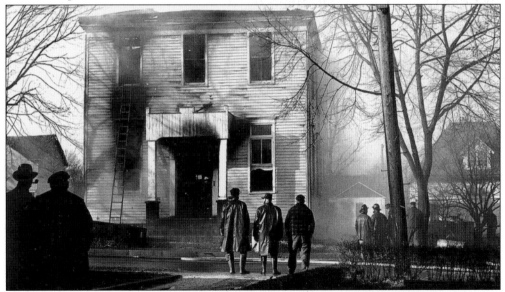

In January 1951, the former Mechanics Hall building, then owned by Michael Fenske, was destroyed by fire. The Monmouth Junction Volunteer Fire Department fought the blaze with six outside units for four hours. Personnel from the local plants of Columbian Carbon, Frederick H. Levey, and Ridge Door were released from work early to fight the blaze. When the fire hoses were finally turned off shortly before 4:00 p.m., all that remained of the historic building were the charred walls.

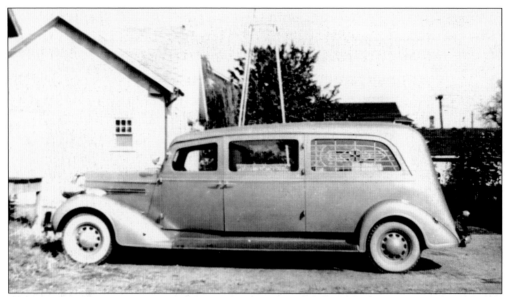

The Monmouth Junction First Aid Squad began as part of the Monmouth Junction Volunteer Fire Department. Former Chief Dave Stewart was asked to establish a rescue service. William Van Dyke was elected president, William Voorhees captain, and Jack Ritter treasurer. The squad raised money through ongoing scrap paper drives and cleaning Princeton University's Palmer Stadium after football games. Through these efforts, it was able to purchase Dunellen's 1937 Dodge Ambulance (shown here) for $800.

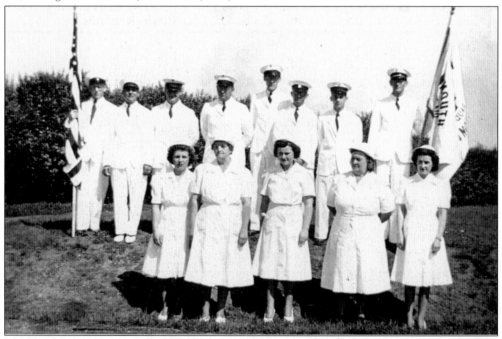

In 1942, many of the men went off to serve their country and the women of joined the Monmouth Junction First Aid Squad. The women had to become members of the fire department first in order to join the squad. From left to right are unidentified, Maude Voorhees, Marilyn Ryan, Mae Brabson, and Agnes Schuh Brabson.

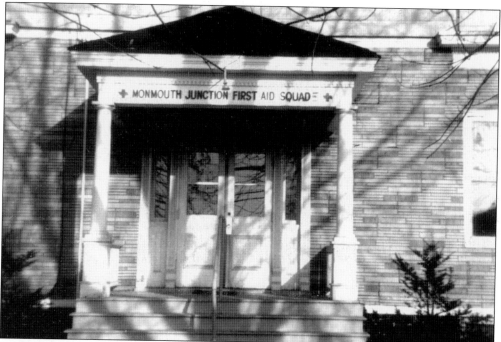

The Monmouth Junction First Aid Squad became independent of the fire department after it acquired its own insurance policy, stopped holding meetings at the fire department, and moved into the old Monmouth Junction School on West New Road. The squad demolished this building *c.* 1974 to make way for the new brick building that stands there today.

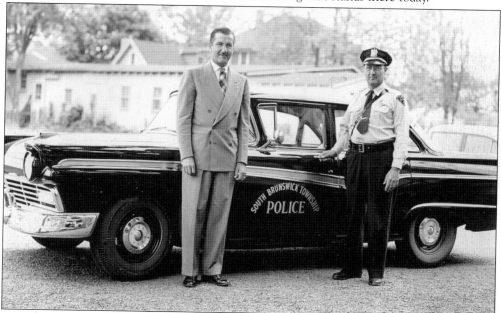

In 1935, the South Brunswick Township Committee decided to establish a police force. Fred Holsten (right), a school bus driver, was appointed as part-time police chief. William Voorhees. Anthony Delre covered the Monmouth Junction area. James McDonald covered the Kingston area. Pictured in 1957 with Holsten is township committee member Lester Sohl.

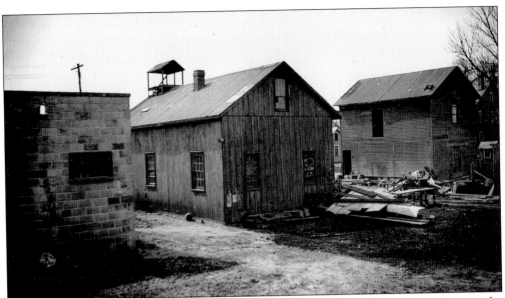

The Kingston Volunteer Fire Company No. 1 was established in 1924, as a reaction to the number of fires that had taken place in the village. In 1926, the fire company paid Matilda Shann, widow of undertaker and wheelwright J. Watson Shann, $3,000 for property located on Railroad Avenue (now Heathcote). The building pictured in the center of this late-1920s photograph housed J. Watson Shann's hearse and the fire company's first fire truck, a 1924 American LaFrance Brockway.

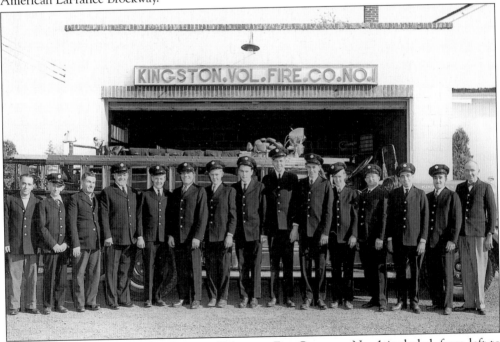

In the 1950s, members of the Kingston Volunteer Fire Company No. 1 included, from left to right, John Casualy, William Burgher, Rocky Devito, George Kirby, George Kaltschmid, Robert Brian, Chester Potts, Willie Kuderka, Lea Luck, Ralph Klieber, Harry Place, Dave Taglioli, Joe Catelli, Armond Petrillo, and Raymond Wolfe.